Phaidon Press Limited
140 Kensington Church Street
London W8 4BN

First published in Great Britain 1992

© Parramón Ediciones, S.A. 1991

ISBN 0 7148 2817 3

A CIP catalogue record for this book is
available from the British Library

Printed in Spain

Learn to draw with

Coloured Pencils

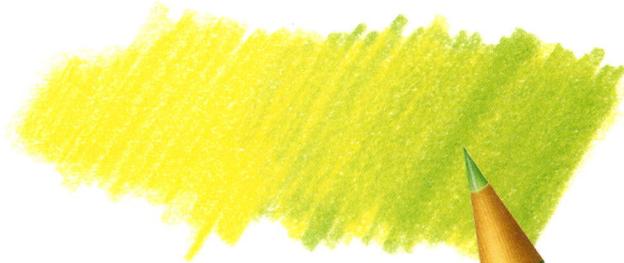

Materials, skills and
step-by-step projects

Φ

Coloured pencils

Learning to use coloured pencils

This book has been designed to help you learn how to draw with coloured pencils. It tells you about the materials you need and explains the various skills used to create different effects with coloured pencils. Start by reading about the basic skills, then follow the step-by-step projects later in the book to practise and gradually improve what you've learned. Any terms you're not sure of are explained in the Glossary at the back.

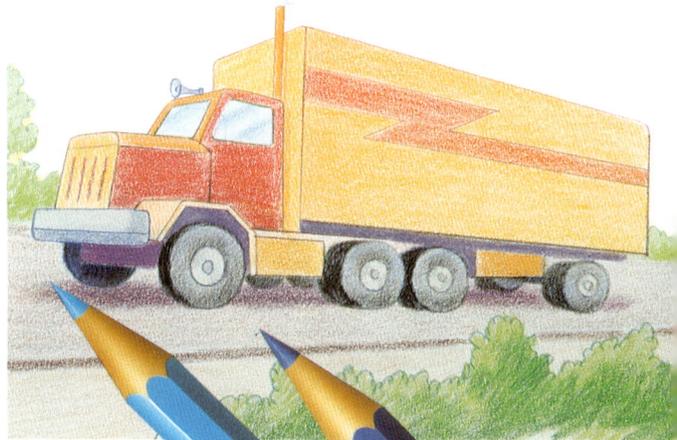

This book is divided into three parts: the first part tells you about the materials you need; the second part explains the skills for using coloured pencils; the third part contains step-by-step projects to follow .

Drawing with coloured pencils

Learning to draw with coloured pencils is the first step towards producing your own pictures.

Drawing with coloured pencils is also a good preparation for using other techniques, such as watercolour, poster paint or gouache. Without having to know how to use a brush, you can learn important lessons about painting, such as:

○ understanding colour

○ how to lighten and darken colours

○ how to mix colours

The pressure you put on the pencil allows you to achieve different tones, or values:
1 *a little pressure gives you a light tone; slightly more pressure will give a medium tone; strong pressure will give a dark tone, covering the grain of the paper. With crayons you will also learn:*
2 *to gradate colours and*
3 *to mix them.*

1

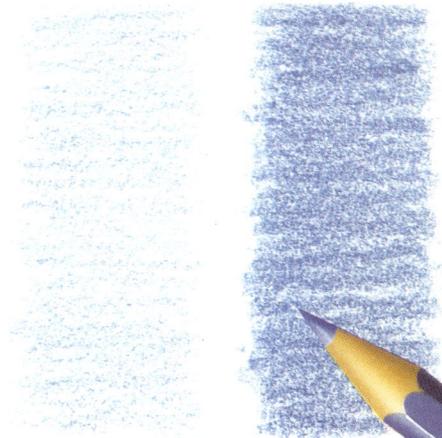

light medium strong

2

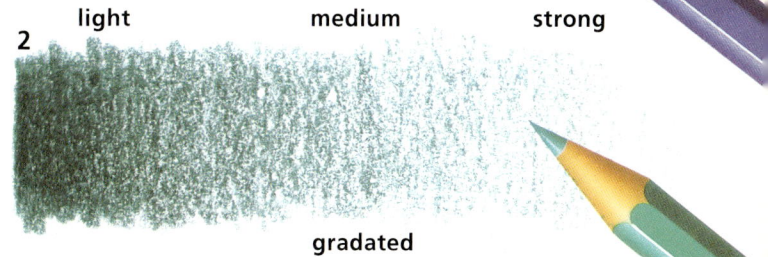

gradated

3

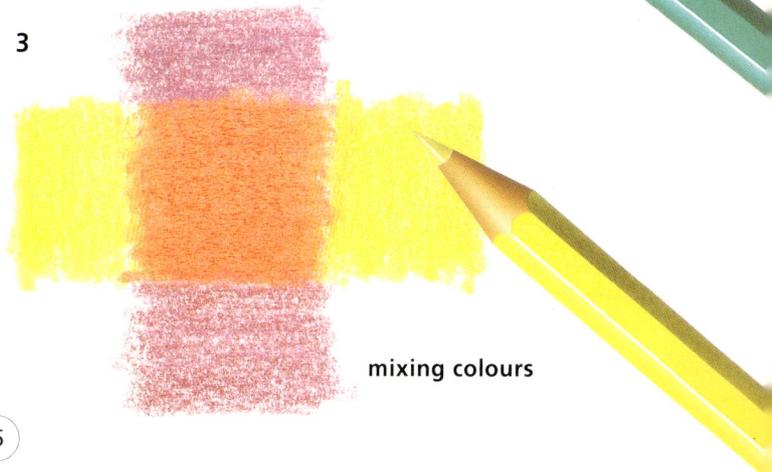

mixing colours

What are coloured pencils?

How coloured pencils are made

The lead in coloured pencils is made of pigments bound with wax and a type of clay called kaolin.

This is the main difference between coloured and graphite pencils.

Graphite pencils have several different degrees of hardness, while coloured pencils have just one degree, generally called either soft or semi-soft.

Graphite pencils – the ones next to these marks – have different degrees of hardness, from B or soft pencils, through to HB or semi-soft pencils, to H or hard pencils. This gradation doesn't exist for crayons, which are usually semisoft. On the right you can see a cross-section of a crayon showing 1 the lead in 2 a wooden covering.

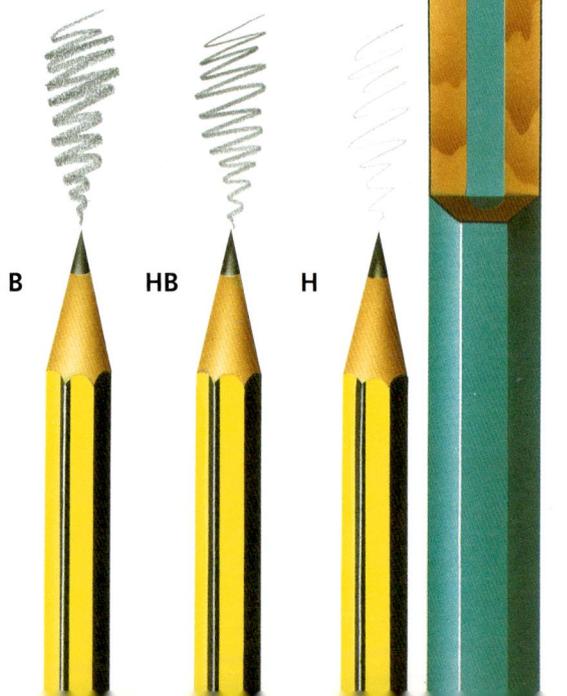

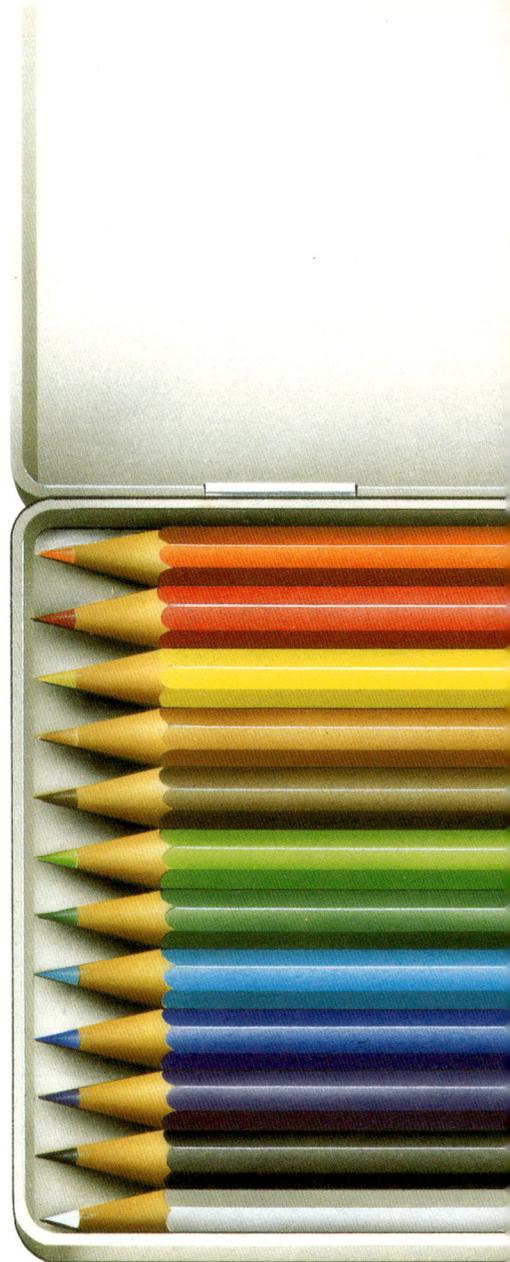

B **HB** **H**

1

2

How to choose them

A 12-colour box provides all the colours you need. You could work with only the three colours on the right. These are the primary colours, which you can read about on page 18.

To begin with, just use the range of shades you have in your 12-colour box in order to avoid mixing colours.

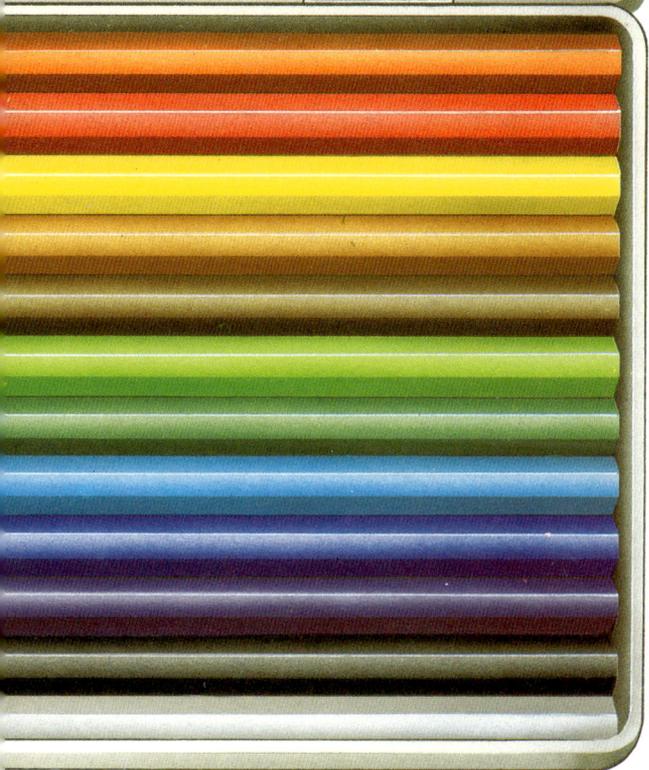

Sets of coloured pencils

There is a great variety of boxes of coloured pencils. Sets are available containing 8, 12, 24, 36, 48, 60 and 72 colours. If you use one of the larger sets, you will have a huge range of different shades. Some artists use these assortments to avoid mixing colours, which may damage the paper grain.

As a beginner, you need an assortment of only 12 colours, including:

1. Orange
2. Red
3. Yellow
4. Yellow ochre
5. Brown
6. Light green
7. Dark green
8. Light blue
9. Dark blue
10. Purple
11. Black
12. White

What to draw on

Papers

The various types of paper are classified according to their weight and texture.

Weight is the paper's thickness measured in grammes. A paper that weighs 80 grammes is a thin paper, whereas a paper that weighs 210 grammes is a thick paper–almost a cardboard.

Texture is the greater or lesser roughness of the paper surface. It is also called paper grain. There are three classes of texture: smooth (hot-press), medium (cold-press) and rough. There are also glossy papers, with a shiny surface.

The best papers for use with coloured pencils have a smooth or medium surface.

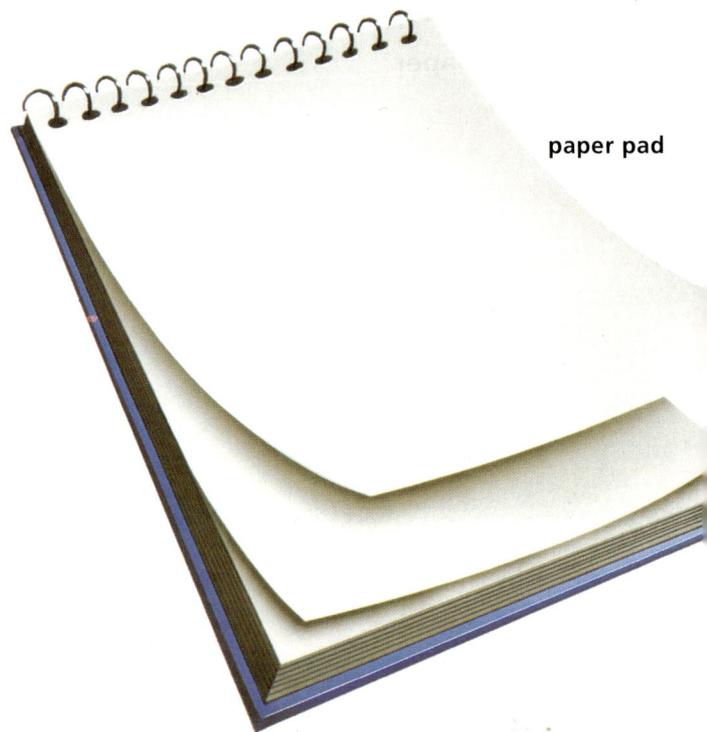

paper pad

medium paper

rough paper

smooth paper

Using coloured paper

Papers vary according to their weight and texture. But you can also choose between white and coloured papers.

The choice between white and coloured paper depends on the subject you are going to draw.

If you draw on coloured paper, the background colour adds to the 'atmosphere' of the picture you are drawing.

Art shops stock a wide range of tones.

On the right you can see the possibilities of working with coloured paper. A paper in the colour of the subject works as an extra background. There is a wide range of colours to choose from, but usually the most suitable are the neutral ones.

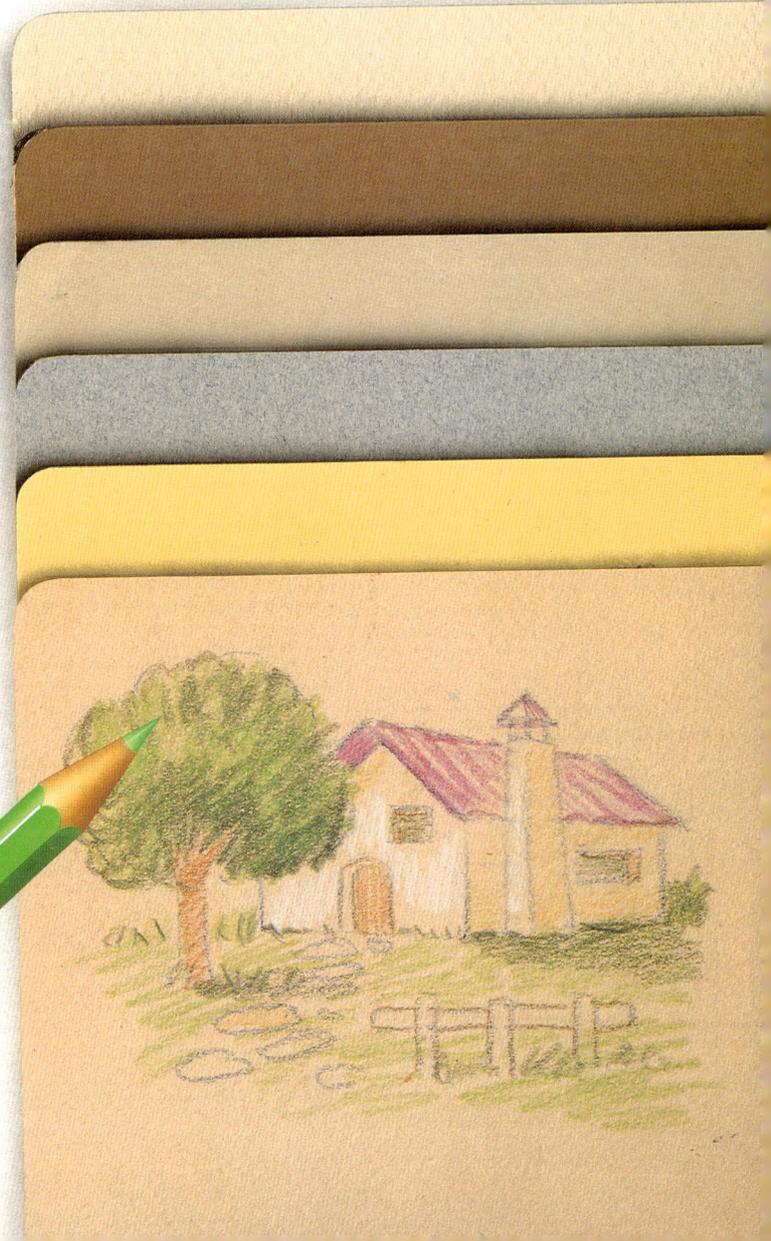

Other tools

What else do you need?

Before starting to draw with coloured pencils you will need to collect together various other materials.

A good point

Coloured pencils need to be sharpened frequently. There are different ways of getting a point on a coloured pencil. You need a pencil sharpener and sandpaper. With sandpaper you can make a very sharp point for fine lines and tiny details. Rub the point horizontally on the paper while turning the pencil.

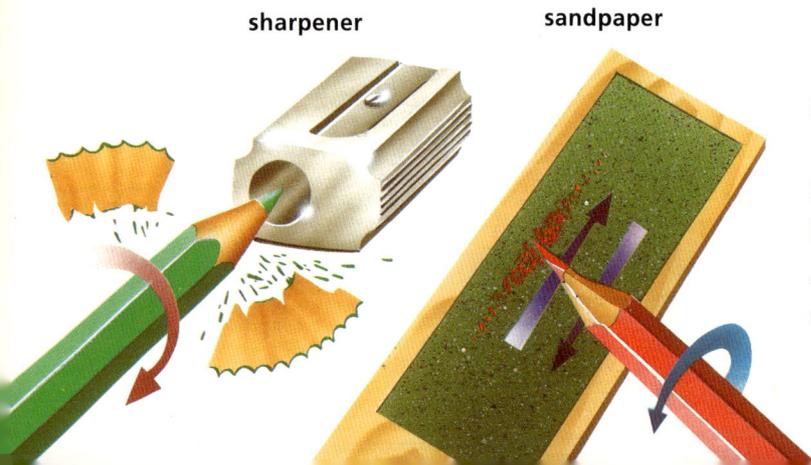

crayons stored point-upwards in a jar

Notice the difference between a pencil sharpened **1** *with a knife and* **2** *with a pencil sharpener.*

sharpener　　**sandpaper**

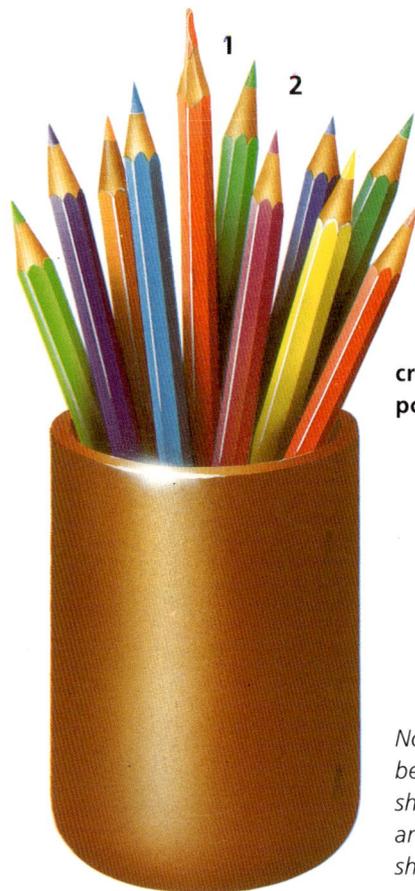

Storing your crayons

Make sure you always have crayons to hand by keeping them in an earthenware, glass or plastic jar. Always keep your crayons with the point facing upwards so their sharpness is not blunted.

Making work easy

Choosing the right work surface

A sloping board is ideal for working comfortably. You can hold it on your knees and lean it against the table edge.

If you use a wooden board, try to get a spring clip like the one in the illustration to hold the paper in place on the board. You can also use drawing pins for this.

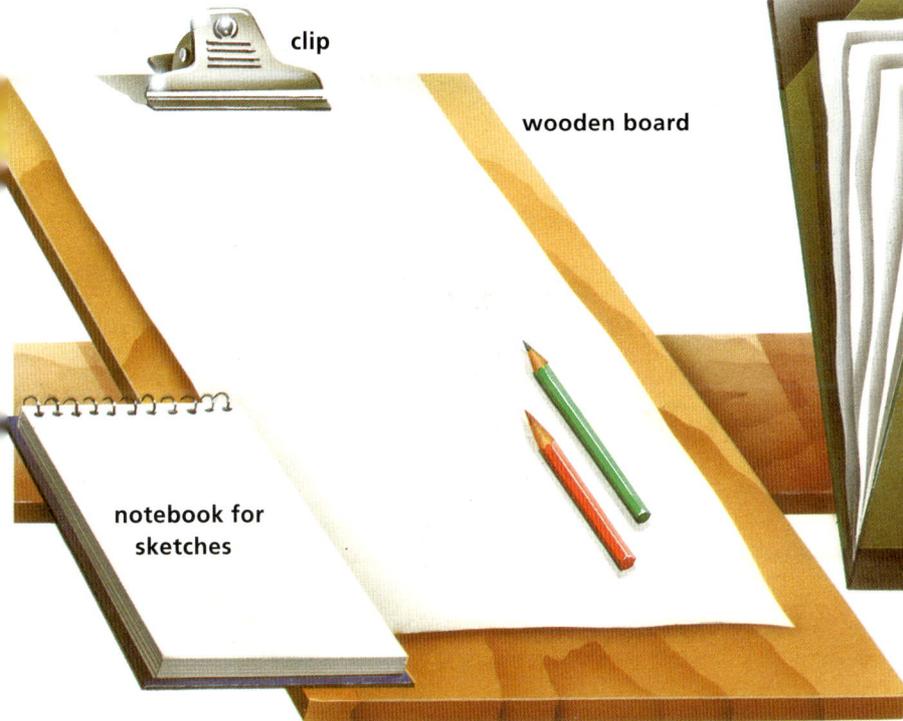

Making sketches and storing pictures

You will need a notebook for making sketches in preparation for your final drawings.

Keep your work in a large folder. Place sheets of paper between the finished pictures.

clip

wooden board

notebook for sketches

folder

Drawing skills

Holding a coloured pencil

To draw with coloured pencils, hold the pencil between the first two fingers and the thumb, as you normally grip it for writing. This is the best grip to use when drawing details or small areas.

Hold the pencil at a slight angle to the paper.

When colouring a large area, such as a background, it is better to hold the pencil almost horizontal to the paper, with the shaft in your hand.

Two ways of holding the pencil. You need to find a comfortable grip which enables you to use the crayons accurately.

For fine lines or details, hold the pencil as you do when writing (1). For large areas, try holding the pencil with the shaft in your hand and the point almost horizontal to the paper (2).

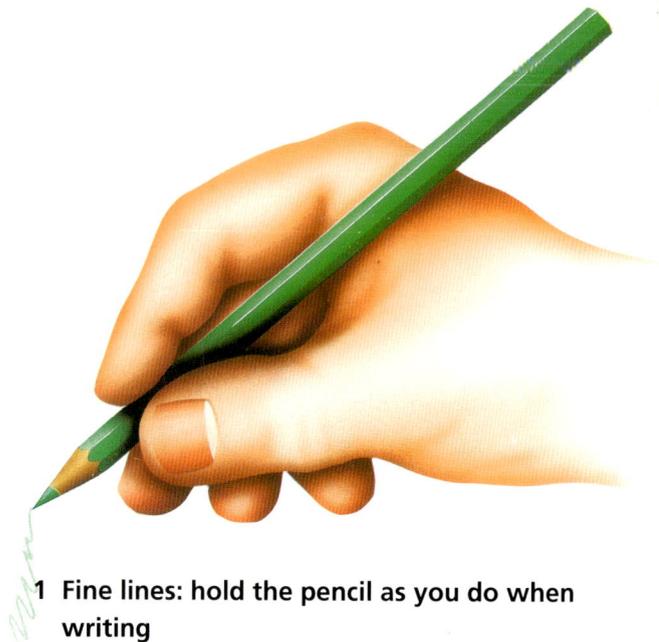

1 Fine lines: hold the pencil as you do when writing

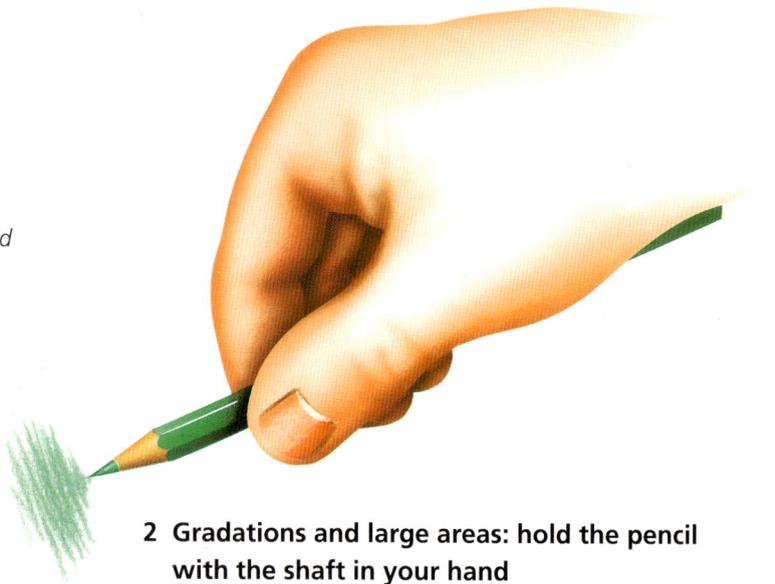

2 Gradations and large areas: hold the pencil with the shaft in your hand

First apply the lighter colour

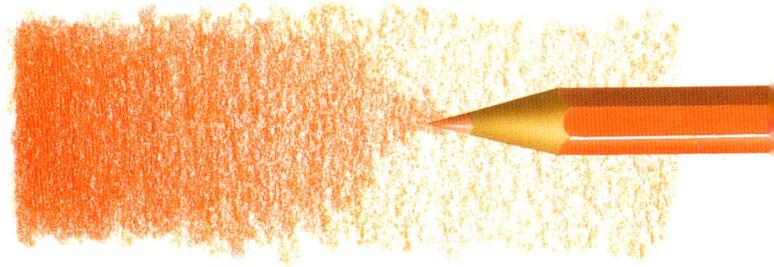

Then add the darker colour

Shading from light to dark

When colouring with pencils you should start with the lighter colours and then gradually cover them with the darker ones.

The lighter-coloured pencils do not cover the darker ones.

Always begin toning gently, using the lighter colours and putting very little pressure on the pencil. Don't forget that the order in which you apply the colours is very important.

Colouring from light to dark, you can deepen tones and mix colours later by putting them on top of each other, as you will see in the following pages.

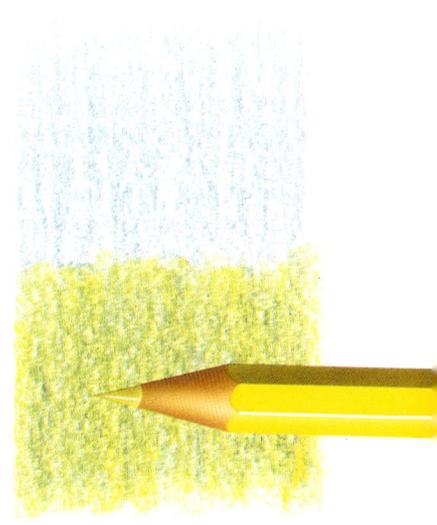

The order in which you apply the colours is very important both for mixing colours and creating tones and values. If you first apply yellow and then apply blue, you will get a dark green. However, if you apply blue first and then apply yellow, you will get a light green.

Drawing skills

Making different tones of colour

By exerting a different pressure on the paper, you will get lighter or darker tones.

You can see this by doing the following:

Colour a wide area in red, pressing gently. The colour will be very light, almost orange.

Then colour again, pressing hard. You will obtain a dark, intense red.

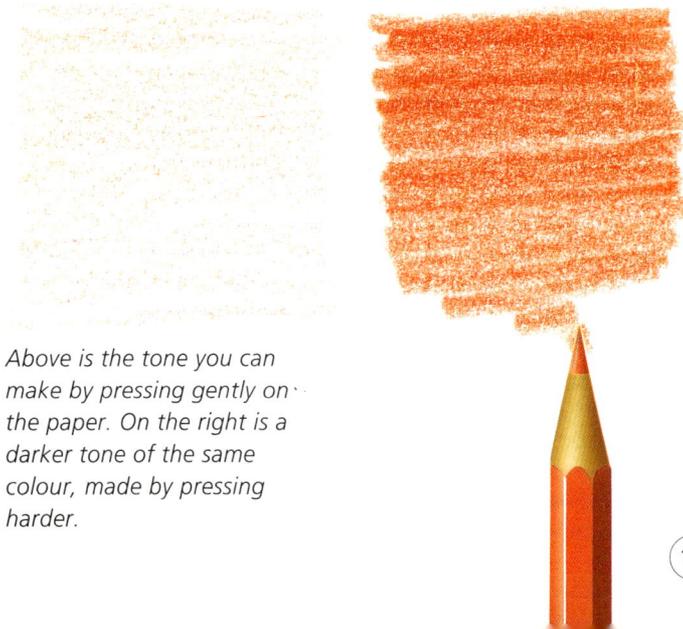

Above is the tone you can make by pressing gently on the paper. On the right is a darker tone of the same colour, made by pressing harder.

Using the right paper

When drawing with coloured pencils, the results will greatly depend on the paper grain.

If you press gently on the paper, the pigment will not cover the tiny bumps on the surface of the paper. If you press hard, the white bumps will be filled in.

It is not a good idea to press too hard on the paper. You could destroy the paper grain, and create a smooth surface on which the pencil would slide.

colouring on medium-grain paper

The choice of paper grain will affect the final result. When drawing with crayons use fine and medium-grain papers.

1

2

A tip for beginners

When working with coloured pencils, the first drawing should be made with a colour which blends with the main colour of the picture.

If you are worried about drawing with a coloured pencil, the following method will solve the problem:

3

○ Draw with a graphite pencil on tracing paper. You can rub out the parts you don't like until you are happy with the drawing **(1)**.

○ Smudge the back of the tracing paper with a soft pencil **(2)**.

○ Place the tracing paper on the drawing paper, dark side down, and go over the drawing **(3)**. Then, simply redraw it with a crayon **(4)**.

4

Drawing skills

Making gradations

To make a gradation you need to know how to achieve different tones of a colour, from the darkest to the lightest.

It is not difficult but you will need to practise using the pencil with various pressures to create different tones.

First, take a red pencil and begin by pressing hard on the paper and then gradually reducing the pressure.

Keep your strokes rather short so that you can make a zigzag from top to bottom without stopping.

At the end, you should be scarcely brushing the surface of the paper.

In some places you will still have irregular tones or lighter tones. Retouch these with great care, applying more or less pressure to match the rest of the area.

Begin by drawing a zigzag from top to bottom, pressing hard at first, then, little by little, more gently until the end, when you will be scarcely brushing the surface of the paper (1). Then, retouch areas with irregular tones or lighter tones, pressing just enough, depending on where you are in the gradation (2). The final result should look like illustration 3.

1

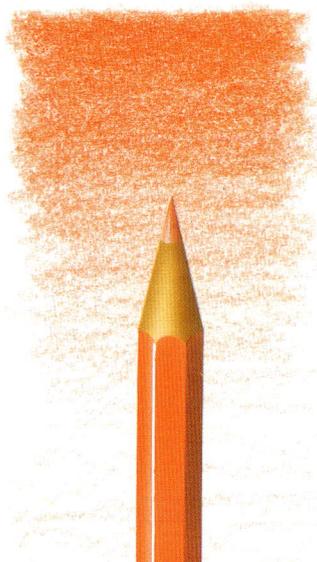

2

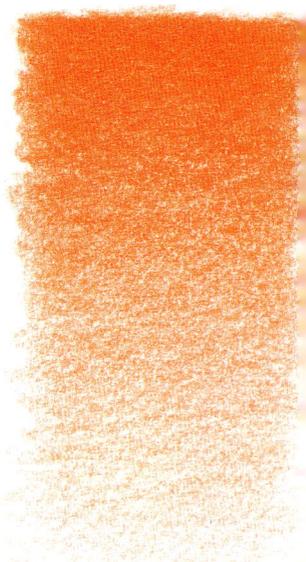

3

Mixing colours

You can mix colours by applying layers of different colours to the paper surface.

The grain of the paper plays an important part in colour mixing.

As you saw earlier, when you draw gently on a fine- or medium-grain paper, tiny white areas are left. If you apply a new layer of colour to the same area you will cover more of the white paper that was showing through.

Applying one colour on top of another produces a new colour in the same way that you can create a new tone by using different layers of the same colour.

When you start colour mixing you will also practise gradations. Notice that when you apply red to a yellow background, the intense colour at the beginning of the gradation changes to a lighter tone when you press gently on the paper. You have mixed yellow with red and have created different tones of orange. In the same way, you get a whole range of tones in green when you mix blue with yellow.

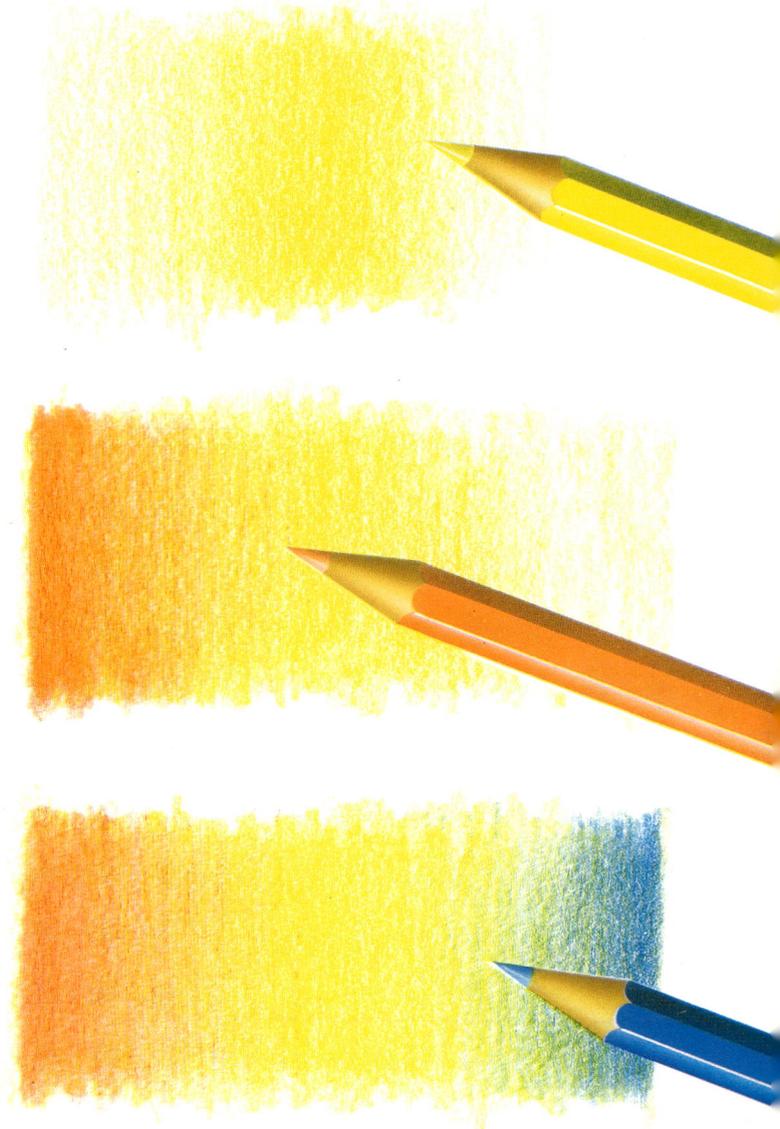

Drawing skills

Discovering the primary colours

There are three basic colours in your set of pencils.

These are the *primary colours*–blue, red and yellow.

When you mix them in pairs, you create the *secondary colours*–purple, orange and green.

By mixing the primary colours and the secondary colours in pairs, you will create the *tertiary colours*, such as blue-violet, red-orange, etc.

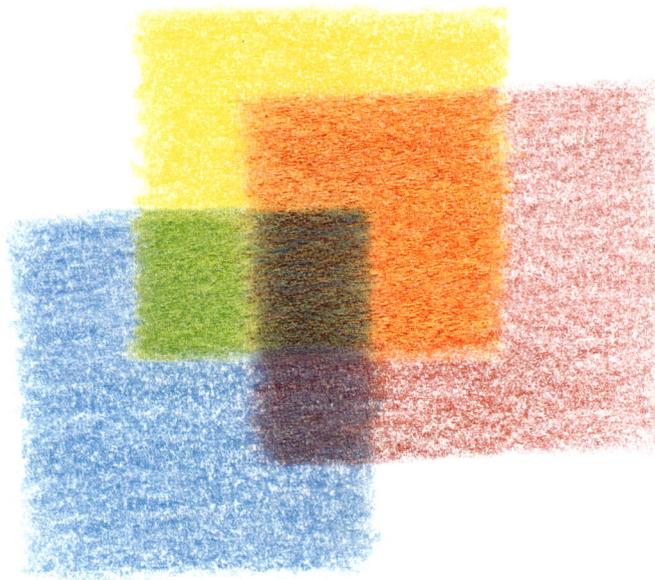

mixing primary colours

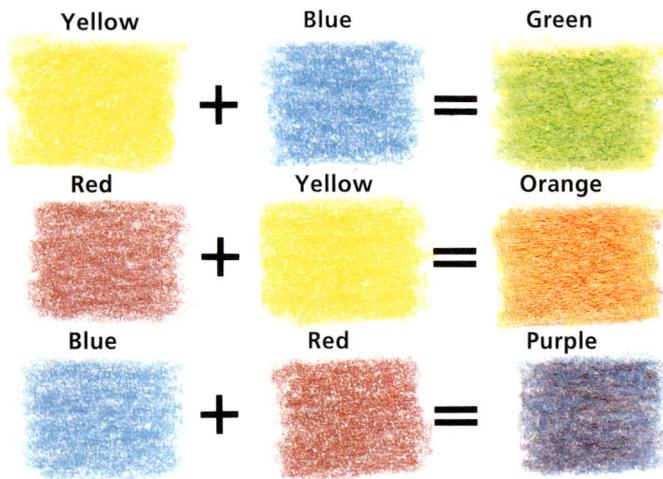

Yellow		Blue		Green
+			**=**	

Red		Yellow		Orange
+			**=**	

Blue		Red		Purple
+			**=**	

Using the primary colours

You can also create all the colours by mixing just the three primary colours: blue, red and yellow.

Practise mixing these three colours. Later you will try using just these primary colours.

The colour wheel

The colour wheel consists of the three *primary colours*, the three *secondary colours,* and the six *tertiary colours,* making a circle of twelve colours.

In the circle you can see several arrows pointing to opposite colours. These are the *complementary colours*. With the complementary colours you can obtain intense contrasts of colour.

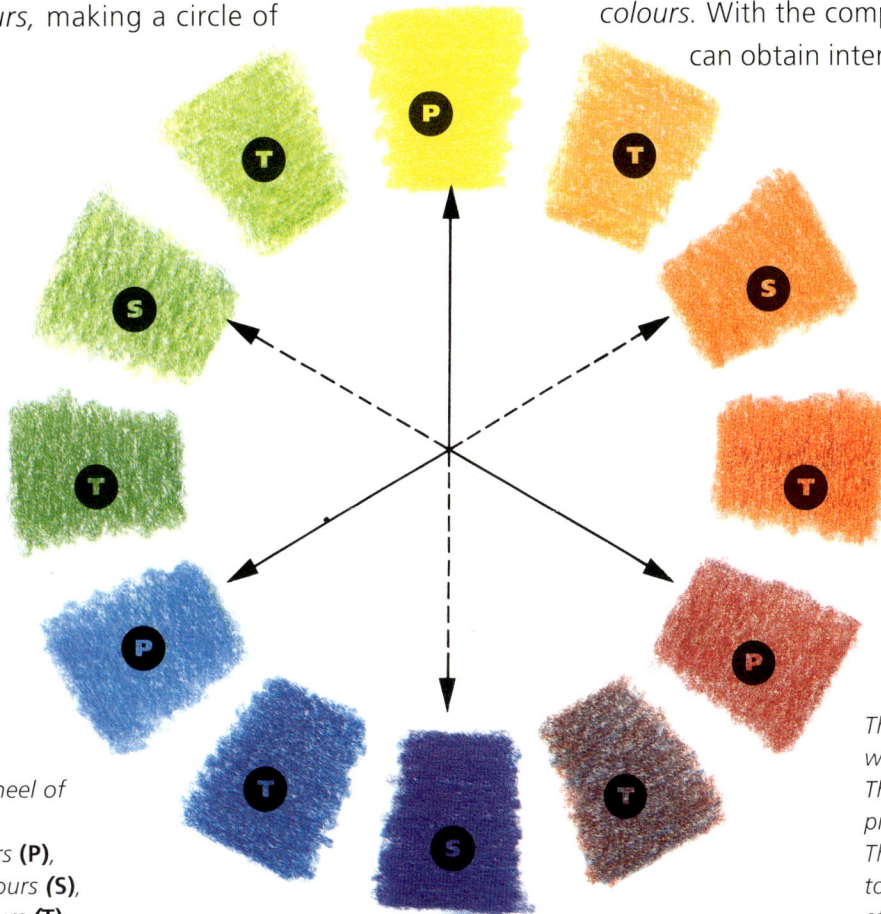

This is the colour wheel of twelve colours:
three primary colours (P),
three secondary colours (S),
and six tertiary colours (T).

The arrows link colours which are complementary. The complementary colours produce the most contrast. These contrasts can be used to create many different effects.

First projects

Draw the balloon outlines in blue; don't press too hard. Leave the highlight on each balloon as blank paper.

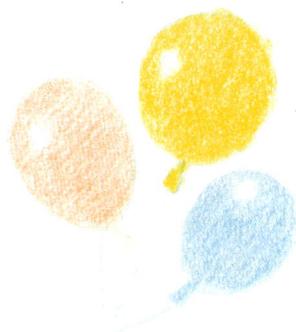

Fill in with colour, holding the pencil horizontal to the paper. Press gently.

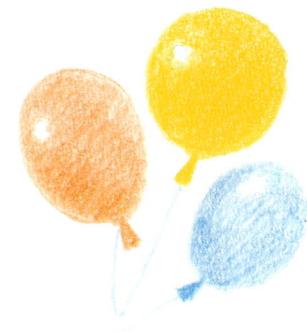

Draw the flower in detail - all the details will be helpful when colouring.

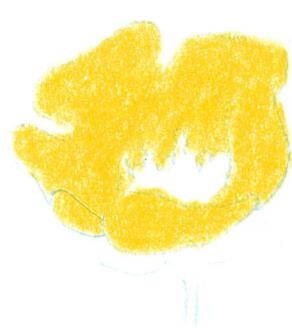

Using gentle pressure, colour the flower petals the same light yellow.

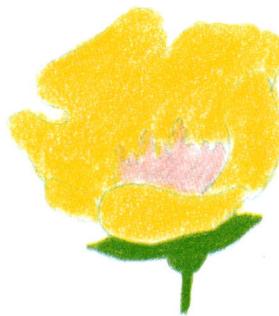

Use the same pencils to create darker tones for the shaded areas.

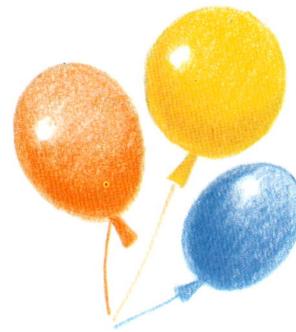

Retouch the shadows and gradate towards the lighter areas to make the balloons look rounded.

Repeat this method, this time colouring the centre, leaves and stem in pink and light green.

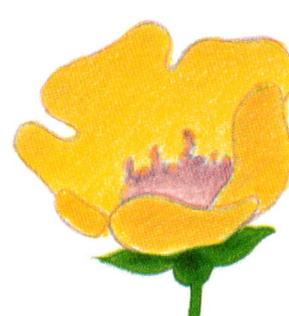

Work on the shadows with dark yellow and pink and outline the shape of the flower.

Make a line drawing, taking care with the proportions, without showing the shadows.

Draw a light yellow overall colour, with the strokes going in the same direction.

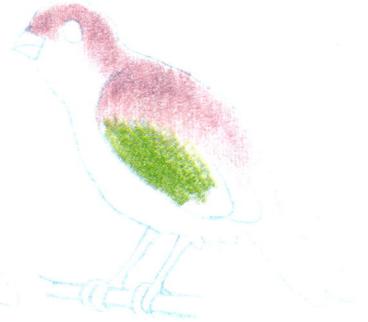

The next step is to begin practising gradations and colour mixing.

Use pink and light green, gently pressing the crayon on the paper, to shade the wing area.

Shape the leaf with pencil strokes, pressing harder on the lower half.

Show volume by pressing harder on the shaded areas and blending the gradation with yellow.

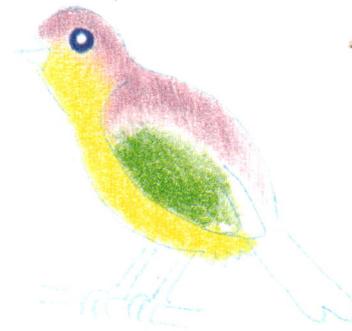

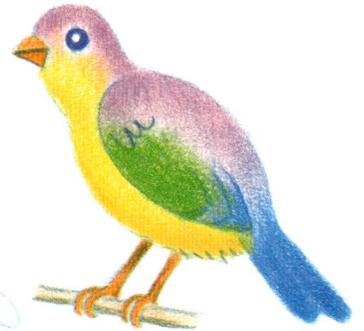

Colour the rest. Use gradation to join the previous colours. Colour the eye purple.

Blend the different colours in the areas in between.

First projects

Make as detailed a drawing as possible. The more details you have, the easier the colouring becomes.

Add the first touches of colour: apply a light yellow background to the front and central stripes of the skateboard. Then apply light green.

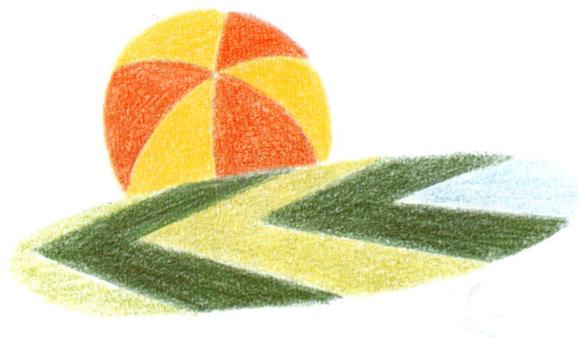

Colour the ball and the remaining stripes of the skateboard. Intensify the stripes with dark green.

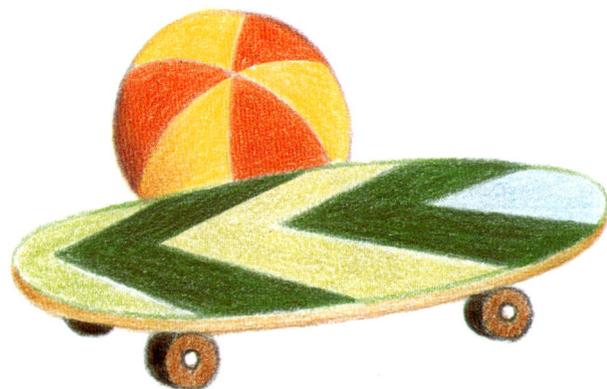

Darken the shadows. Show the volume of the ball by darkening the tones and gradating to the centre. Work on the skateboard colour. Colour the wheels and use black on top of brown in the shadow areas.

First projects

This drawing will help you to practise outlining. Draw the aquarium outline, using a ruler if necessary. Keep your pencils

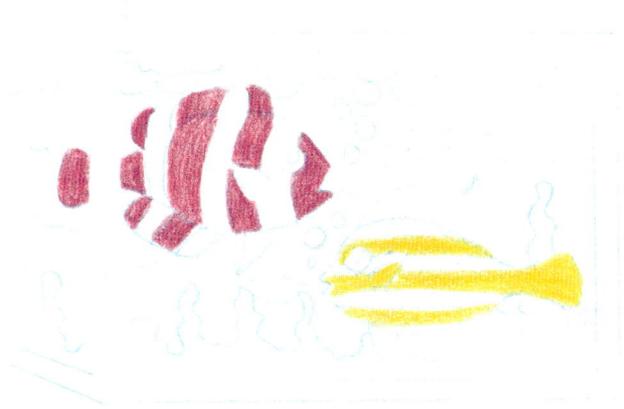

sharpened, as a sharp point will help you to be more accurate. First, draw the outline of each item and then fill it in with colour.

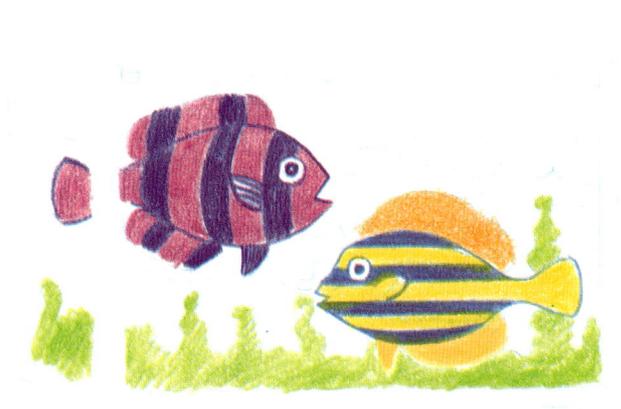

Use light green for the aquarium bottom, always with the same strokes. Deepen all the tones, filling in one fish's fins with orange.

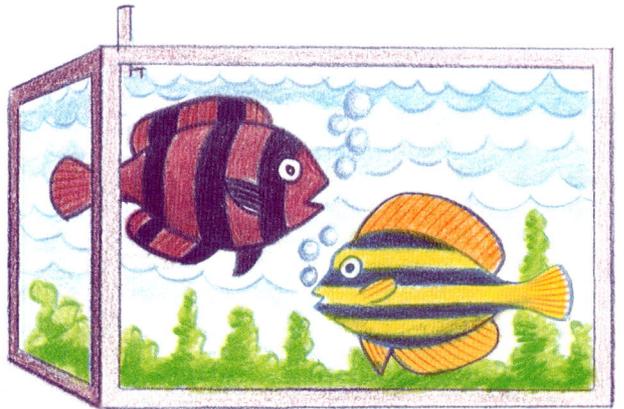

Carefully shade in the water. Press hard with the pencil in some areas and then gradually reduce the pressure. Blend the colours of all the fish and deepen the shadows.

First projects

This drawing, like the previous one, will help you practise drawing outlines and developing dark tones.

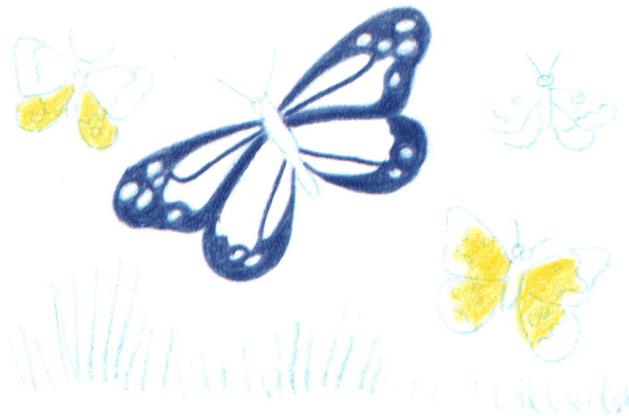

When you start, take care over the large butterfly's wings. Notice the variation in sizes of the markings.

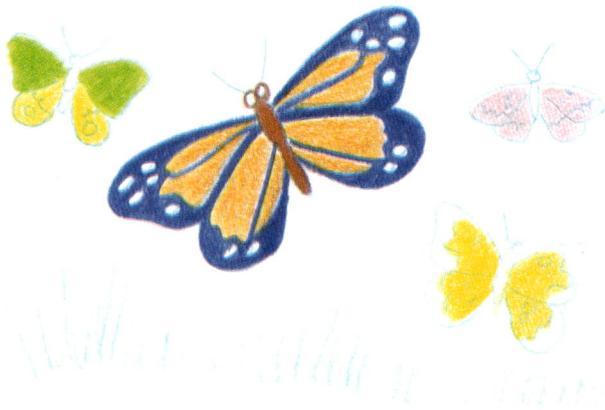

Colour all the butterflies. Hold the pencil horizontal to the paper and make even strokes. Don't press the pencil too hard. Try to create smooth tones that you can deepen later.

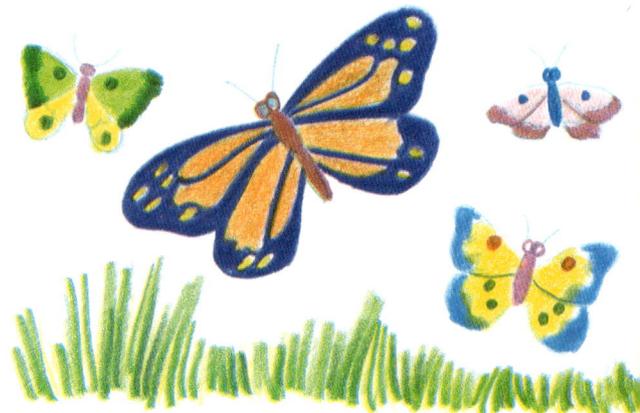

Blend the colours. Then add the details on the butterflies' wings. Make strong strokes for the grass, using dark green on a light yellow background.

This drawing will give you practice in creating shadows and darkening tones. First, carefully draw an outline of the landscape.

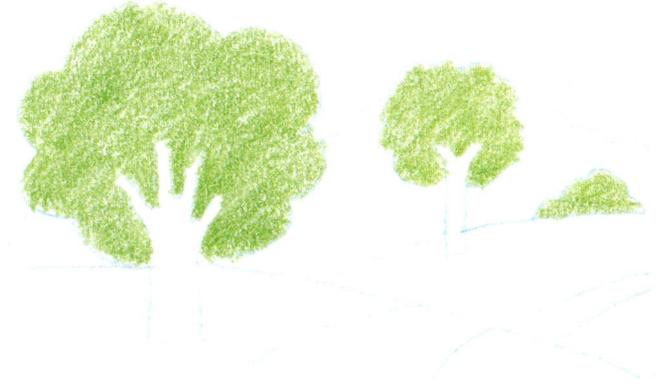

Apply a first layer of colour on the treetops, holding the pencil almost horizontal to the paper, and making all the strokes in the same direction.

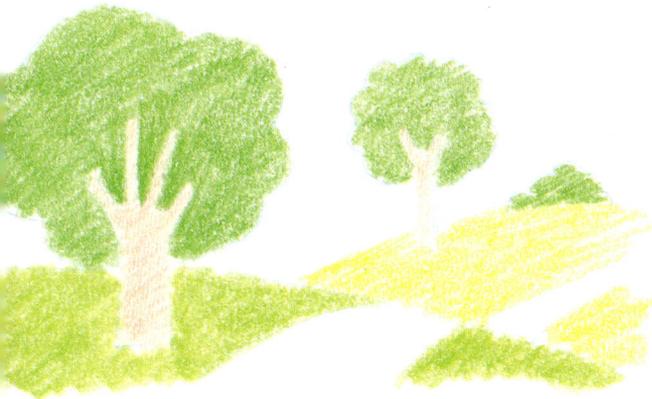

Do the same with light green on the foreground. Use yellow for the first layer of the background. The tree trunks must be coloured with the same kind of strokes.

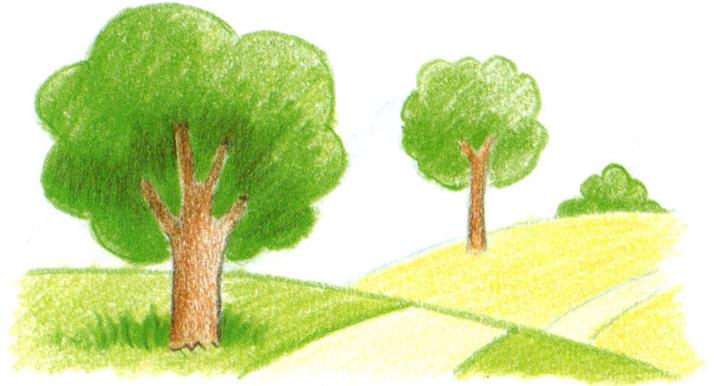

Work the shadows on the treetops with strong strokes. Make a gradation to the centre of the tree trunks, especially in the nearest one.

Advanced projects

If you draw directly with the blue pencil, try not to press too hard. Use a rubber as little as possible when drawing with pencils to avoid smudging the drawing.

Before attempting any further pictures with coloured pencils, here are two suggestions to help you achieve better results:

○ Put a sheet of paper under your hand to avoid smudging the drawing.

○ If you are not happy about doing the drawing with a coloured pencil, draw with a graphite pencil on tracing paper. Then, use the method explained

on page 15 to copy it on to drawing paper. First, colour the blue stripes. Use horizontal strokes from the top to the bottom. Then, deepen the tone using vertical strokes. Draw the outlines of the clouds. Then, begin colouring the sky from the top.

Hold the coloured pencil point horizontal to the paper and draw with horizontal strokes. You should press harder when you start colouring at the top, then reduce the pressure as you work down to the lower area.

Advanced projects

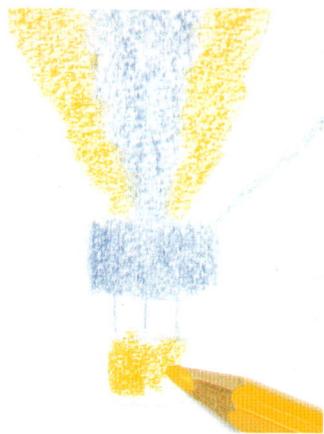

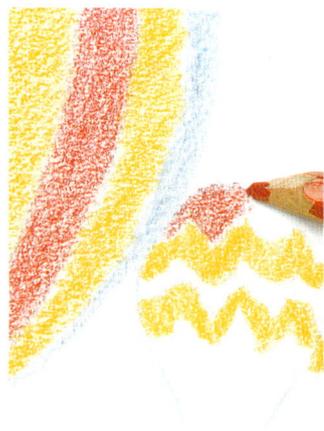

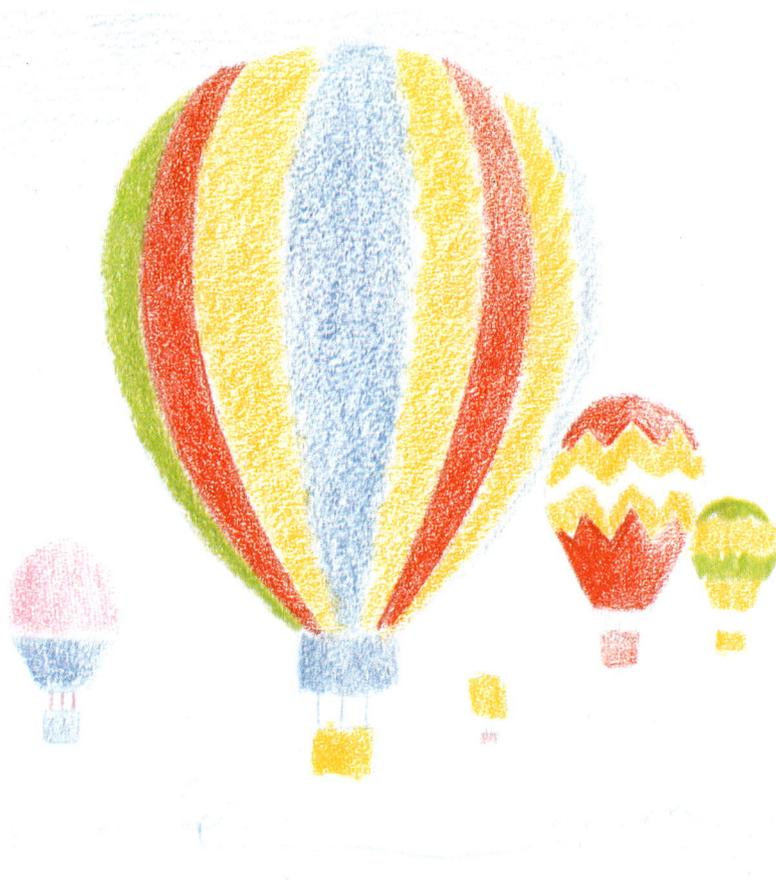

Colour the yellow, red and green stripes of the largest balloon with light strokes, without putting too much pressure on the pencil.

Then apply the first layers of colour on the remaining balloons. Try not to go outside the outlines, especially with the balloon on the right. Apply more colour to all the stripes to create stronger tones.

Advanced projects

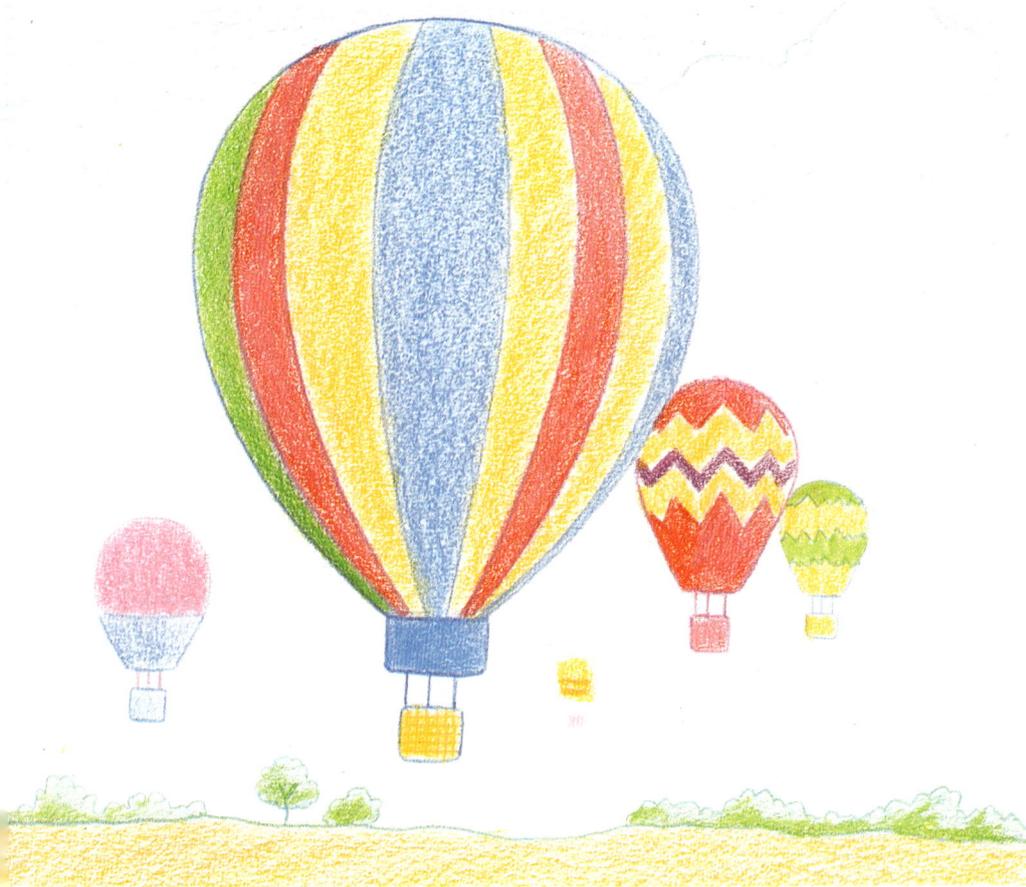

Hold the pencil almost horizontal to the paper and draw with long, sideways strokes to produce the yellow ochre area in the foreground.

Colour the bushes with light green and then strengthen them with some strokes in dark green.

Make long, sideways strokes with yellow ochre in the foreground; deepen the tone with yellow.

Use darker tones of each colour to finish the balloons.

Finally, gradate the blue of the sky with white.

29

Advanced projects

This drawing can be done with only three colours: blue, red and yellow. You'll be surprised at the results.

As you have already seen, by mixing primary colours in pairs, you create secondary colours. Mixing the three primary colours gives you black.

This drawing shows you some of the effects you can achieve using just the primary colours.

Start with the red pencil.

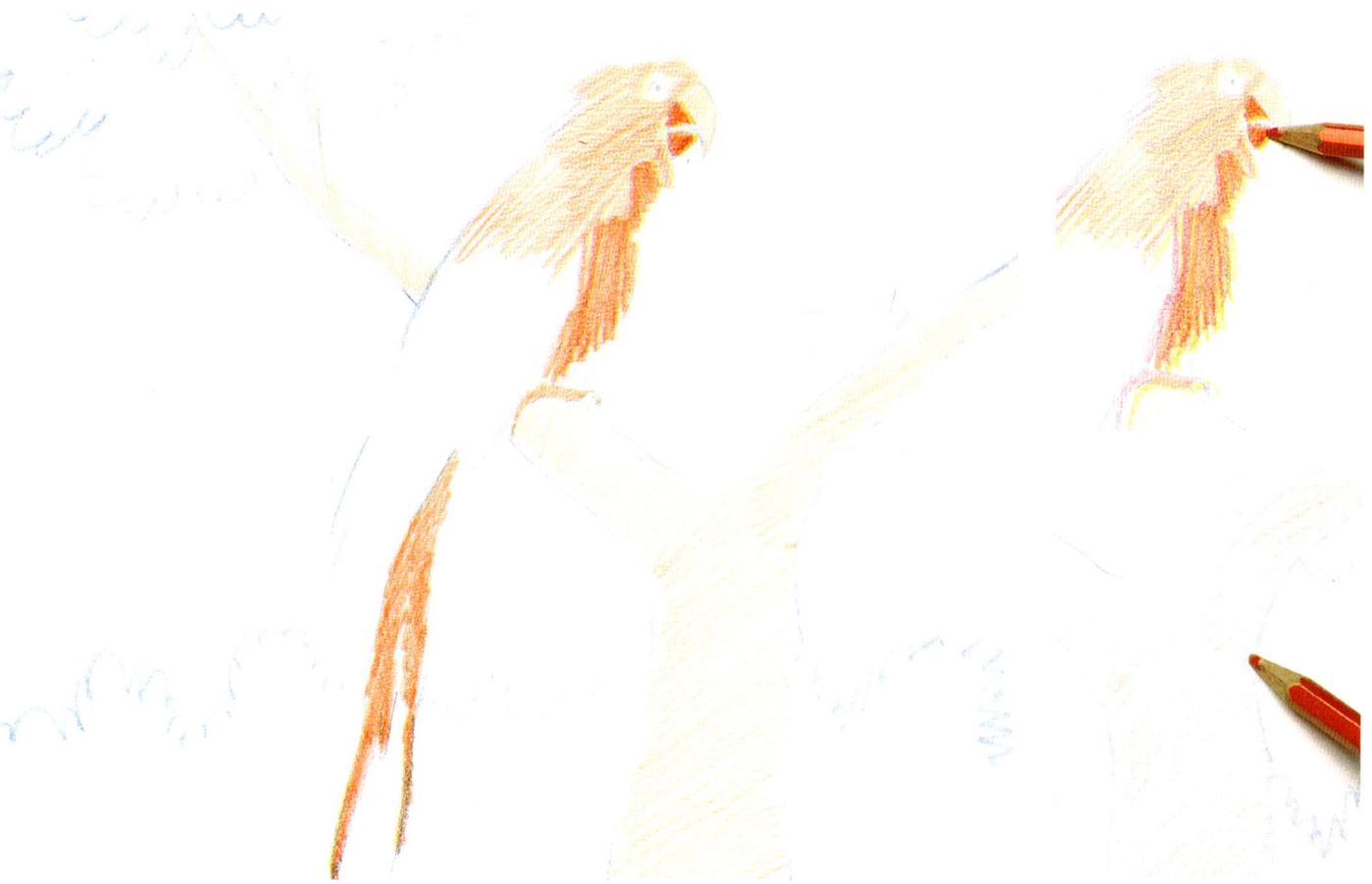

Hold the pencil point horizontal to the paper and press on it lightly.

Press harder, going back over the darker areas.

Remember you should always colour using the same stroke - in this case a straight, sideways stroke. You can see that the stroke for the trunk always goes in the same direction.

Advanced projects

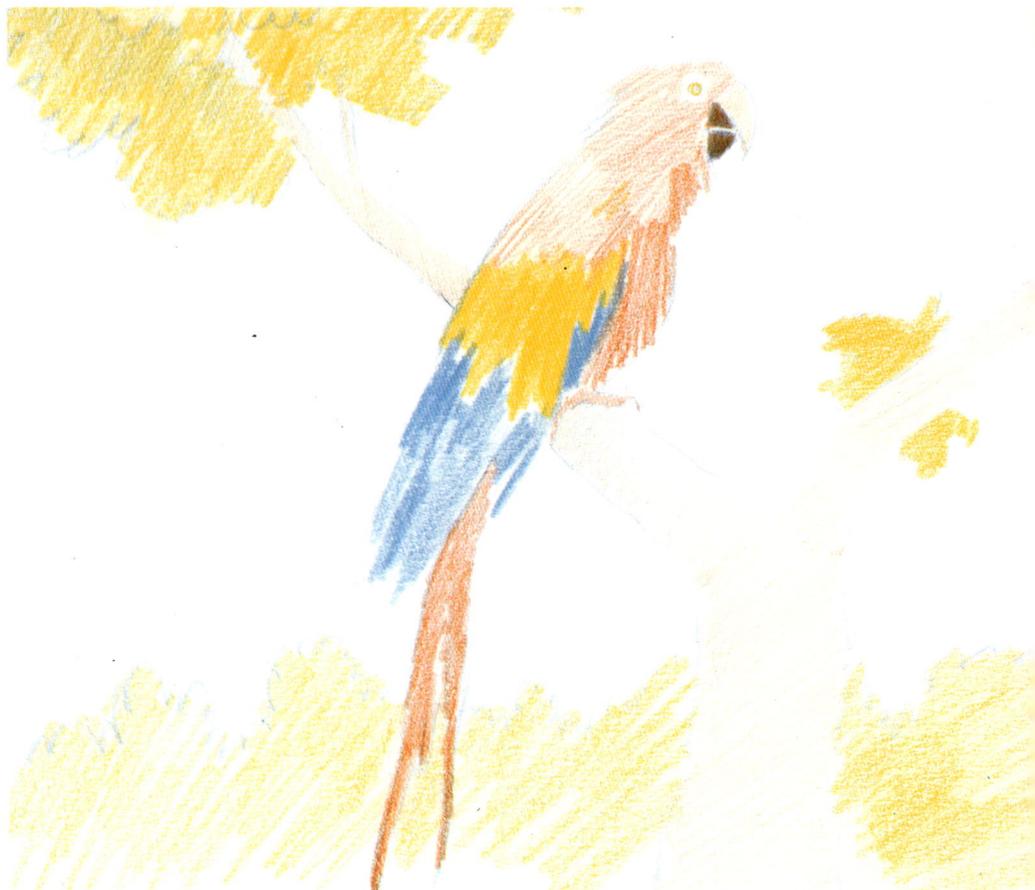

Now add the two other colours.

Add blue over the red for the shadow areas, applying pressure to the pencil. Colour a light layer of blue on the treetop and the bushes.

Add yellow to the darkest area of the feathers and then draw light strokes of yellow over the blue to create the green for the treetop and the bushes.

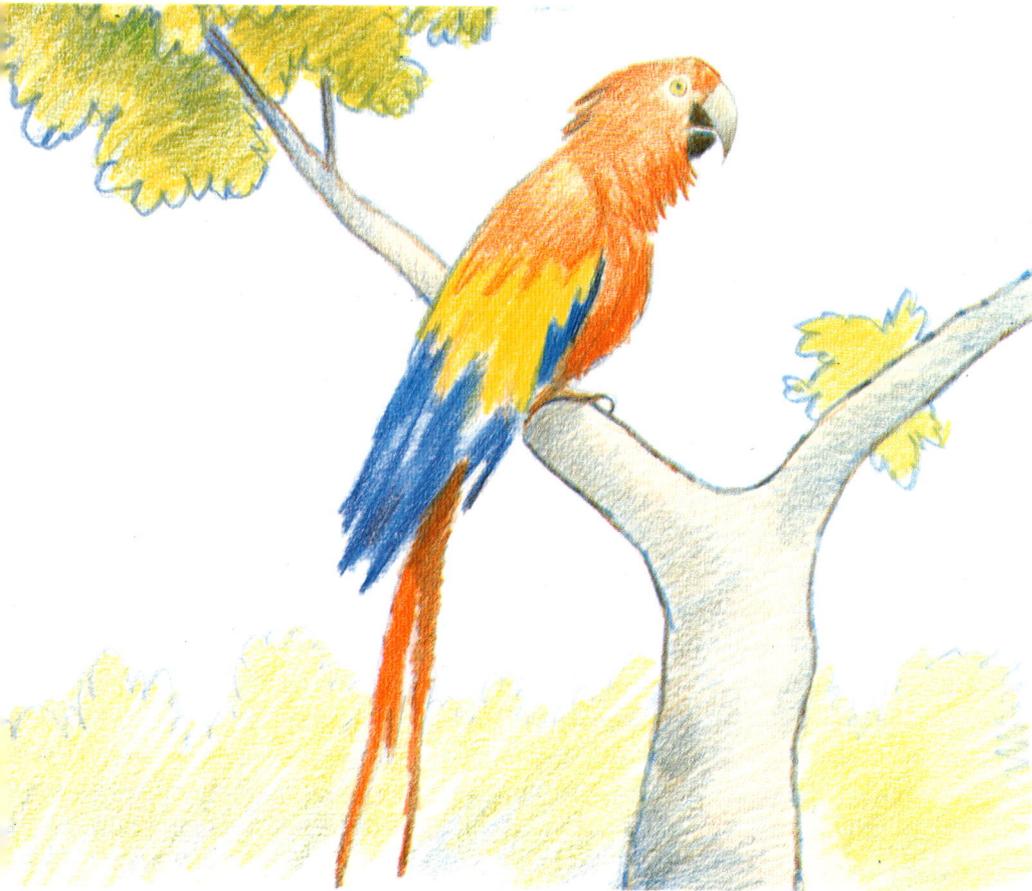

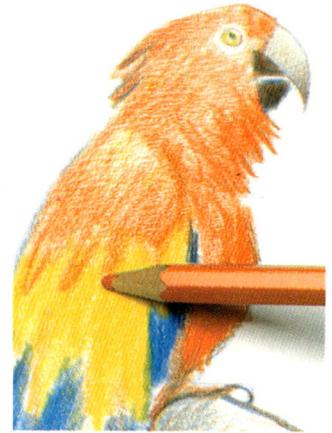

In this finishing stage, you mix colours by adding and gradating one colour over another. This is a way to harmonize the areas between the colours.

Add blue to the trunk and the treetop, pressing harder. Then, colour with yellow to give a deep tone. Remember: blue, yellow, blue, yellow...

Draw the outline of the trunk with dark blue and, pressing harder, recolour the shadow areas, pressing more lightly towards the centre. Finally, add light strokes of blue to the bushes to create a darker green.

Advanced projects

This drawing will improve your skill with coloured pencils and help you to practise colour mixing and making tones. Don't forget:

○ *to take care that the strokes have the same direction and width.*

○ *to begin with the light colours; you will deepen the tones gradually. Be careful not to overdo the depth of colour.*

Make a line drawing, outlining the shapes in the landscape and ignoring the areas of shadow.

Be careful when drawing the bridge. The sides and the arch must be in the right perspective.

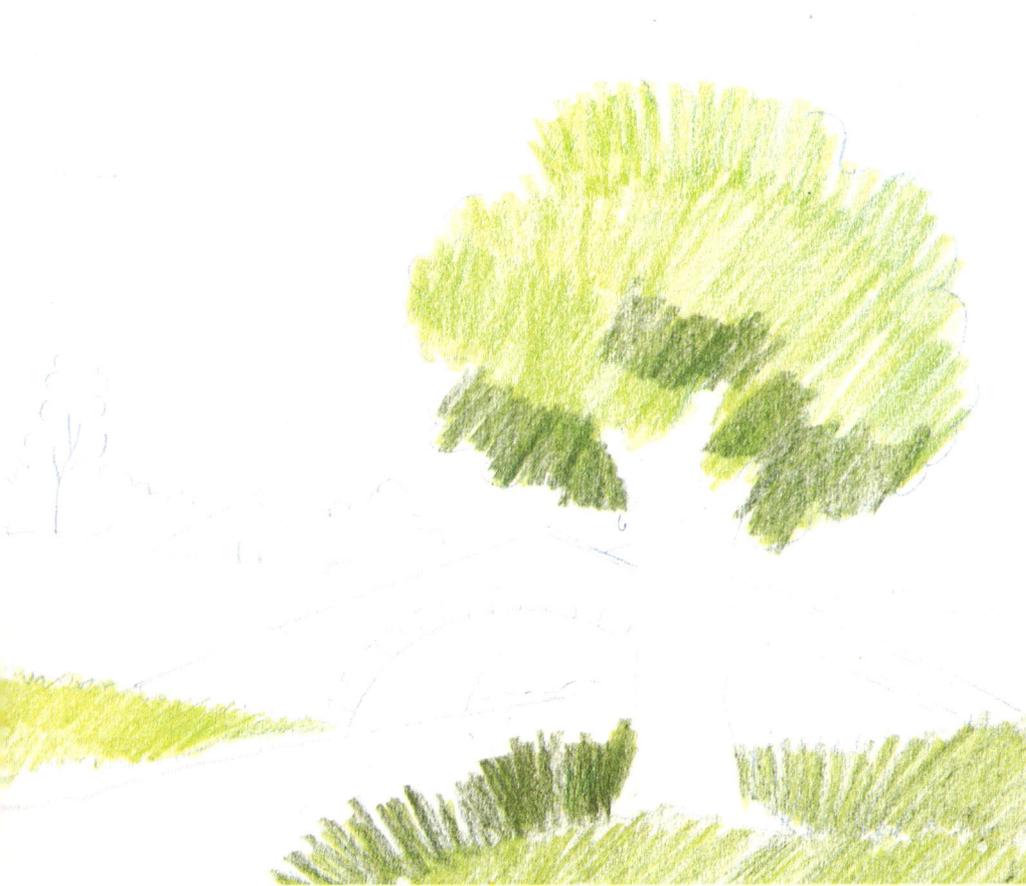

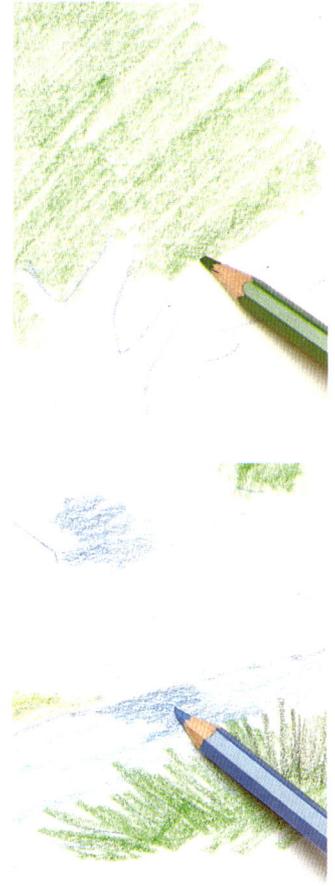

Use light yellow to colour the grass in the foreground; don't press hard on the paper, and draw sideways strokes all in the same direction.

Apply the first layer of yellow to the treetop. Colour the meadow light green and the shadows of the treetop dark green.

Advanced projects

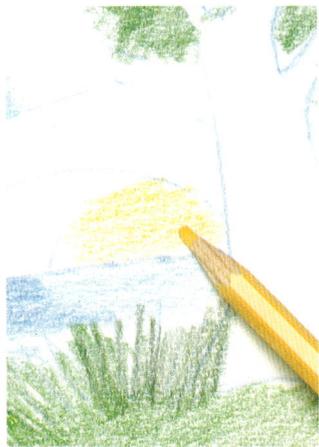

Pressing very lightly on the paper, colour with long, regular strokes for the meadows. Try not to go over the lines of the bridge.

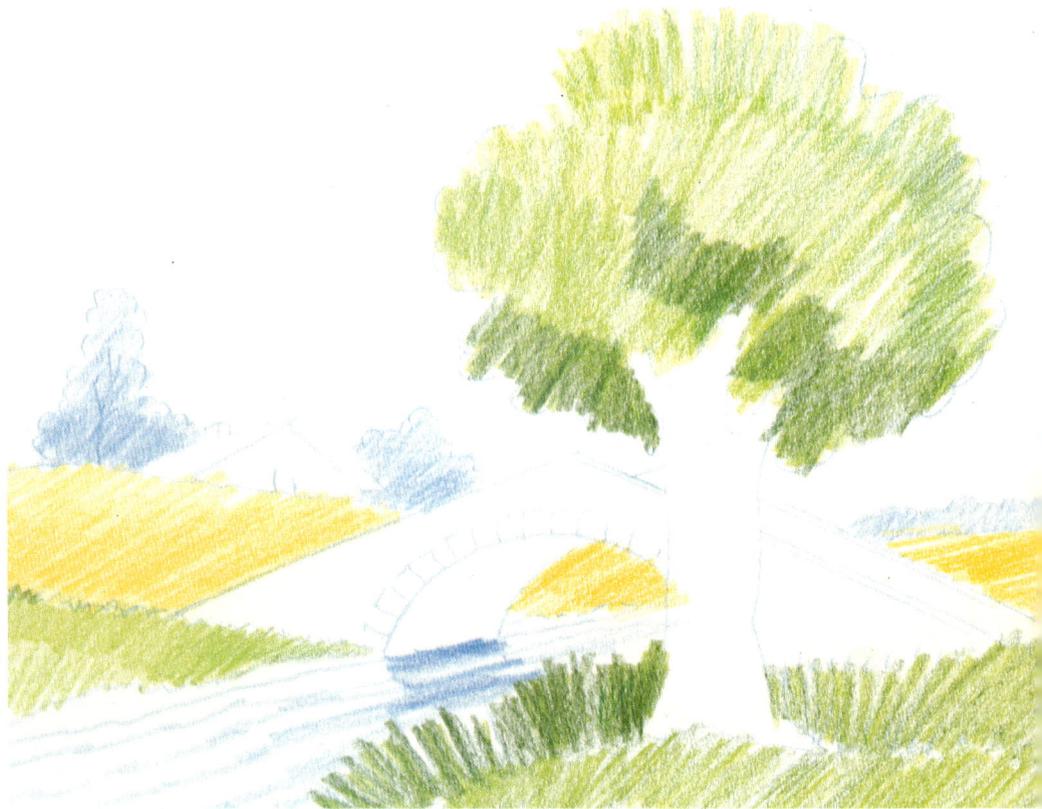

Begin colouring the sky in light blue. To gradate, use the method you've already learned. Press the pencil harder on the upper area and just barely brush the paper on the lower area.

With the same blue, draw ripple strokes for the river. Press harder to show the bridge shadow. Shape the trees in the background with loose strokes.

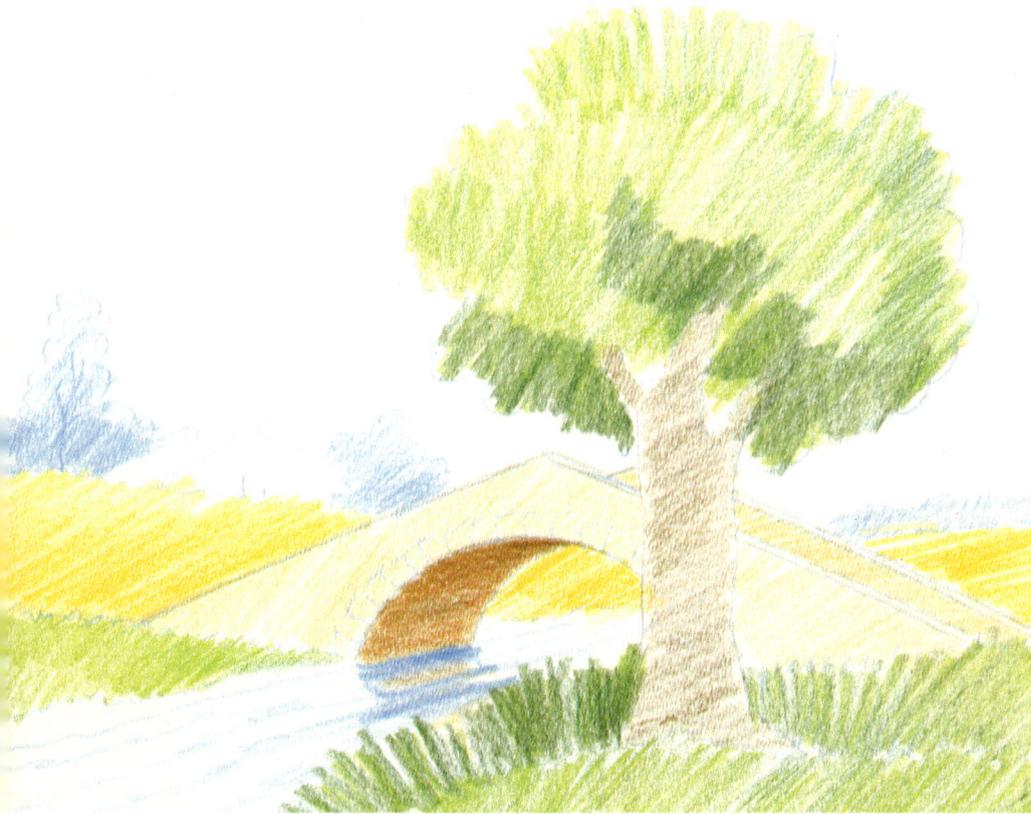

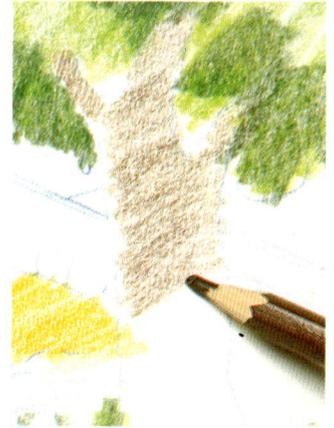

Colour the tree trunk dark brown with regular strokes in the same direction.

Fill in the bridge front with light brown, using even pressure to give an even tone.

Do the same for the underside of the arch, pressing a bit harder.

Mix light brown on to the bridge reflection in the water. Blend with very light blue.

Advanced projects

Colour with irregular strokes, pressing the pencil harder on the paper to deepen the colour in some areas of the river.

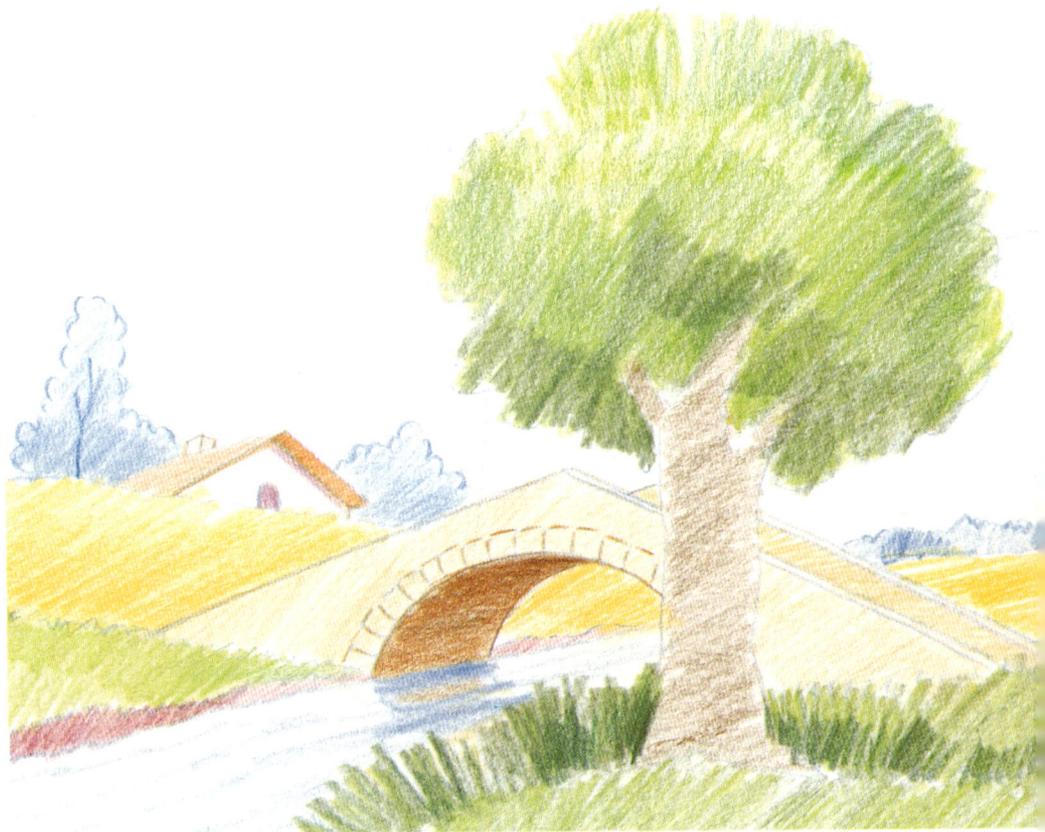

Use the red crayon to colour the roof, barely pressing on the paper. Deepen the tone of the shadow under the roof.

Colour the chimney.

Draw a red line at the edge of the river bank. Deepen the shadows with dark blue.

Now, create dark tones to achieve the feeling of volume.

Advanced projects

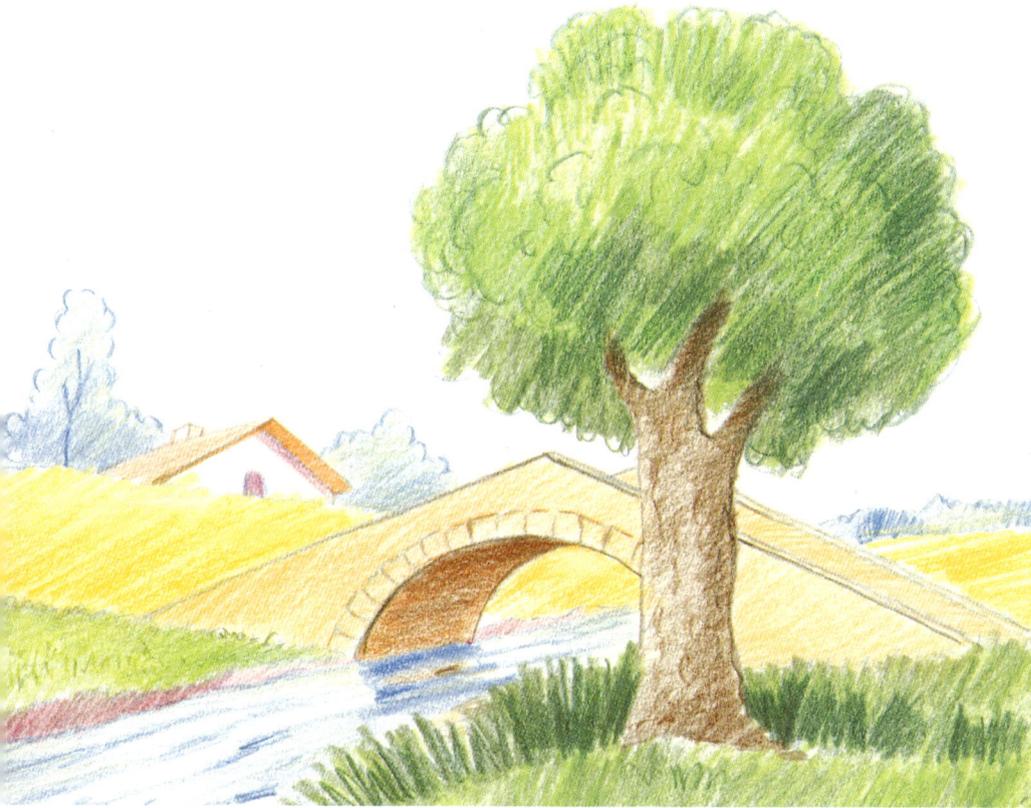

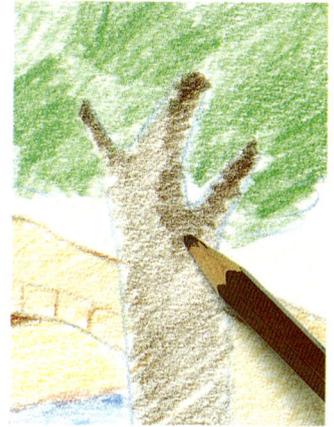

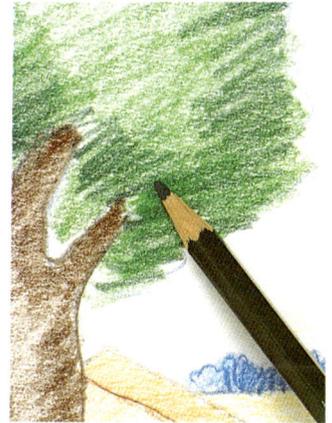

Work with dark green, mainly on the lower right-hand area of the treetop. Draw strong strokes in the same direction as in the rest of the drawing.

Use dark brown on the trunk, with the deepest tones on the outer area gradating to the centre.

Advanced projects

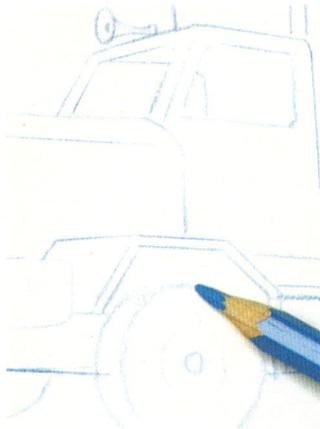

This drawing of a lorry is not difficult. You can use a ruler to draw the straight lines.

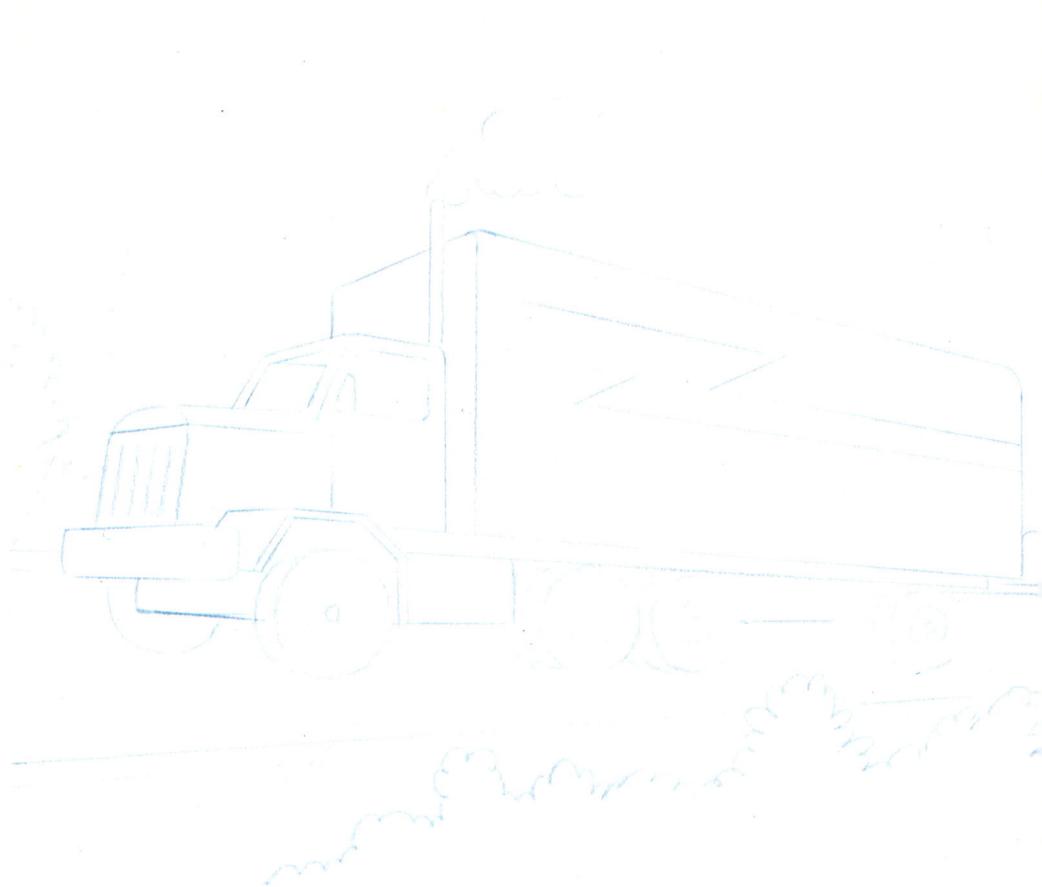

Using either a blue pencil or a graphite pencil, draw the outline, following the previous instructions for this method.

Use a ruler to draw the lorry.

Some artists use paper with grid lines, or tracing paper, to help them with this type of drawing.

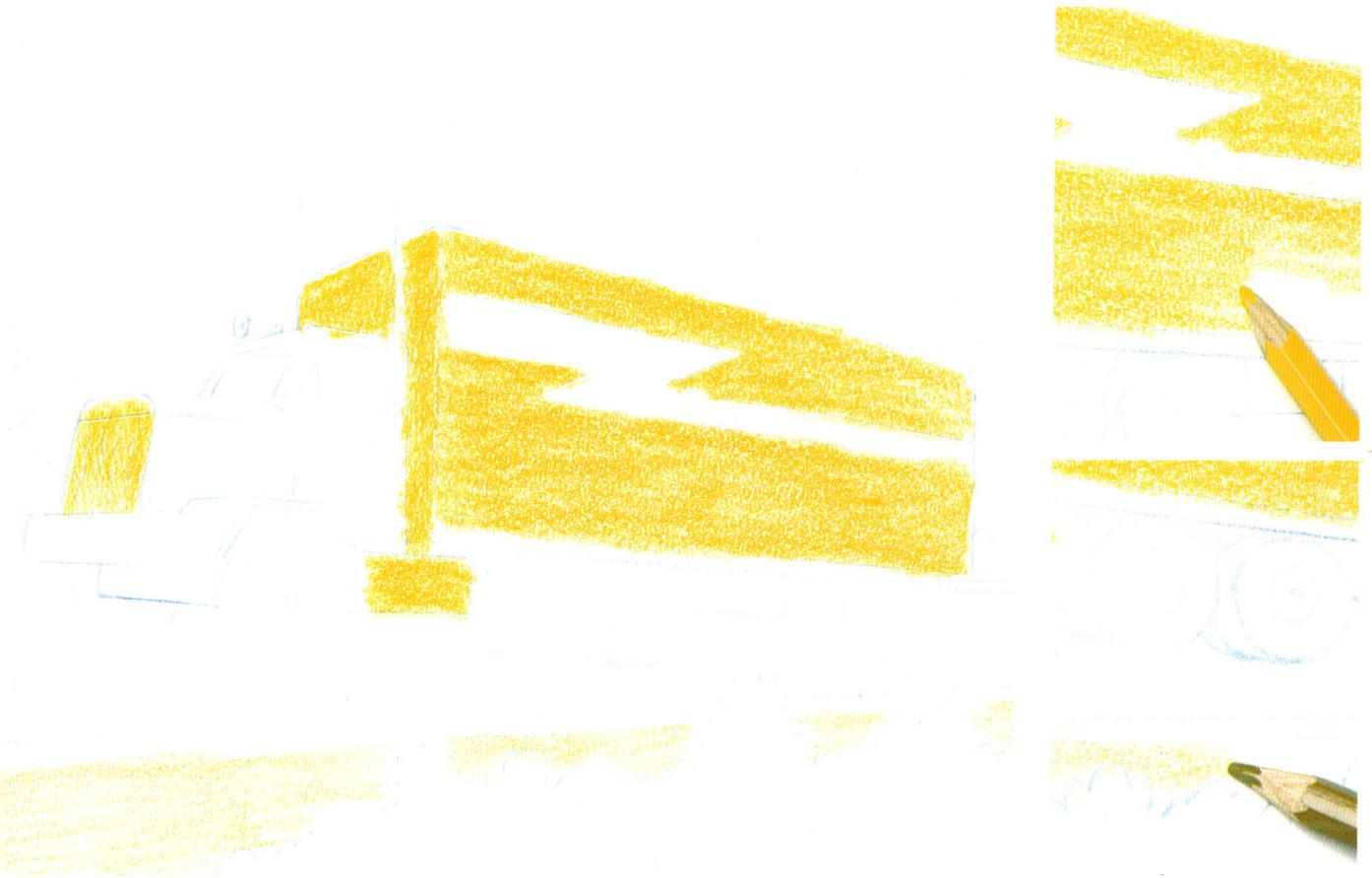

Apply a first layer of colour to the back of the lorry, holding the yellow crayon horizontal to the paper and drawing the outlines accurately.

Gradate with yellow ochre and light brown. Press hard on the pencil for the area by the road and reduce the pressure gradually.

Advanced projects

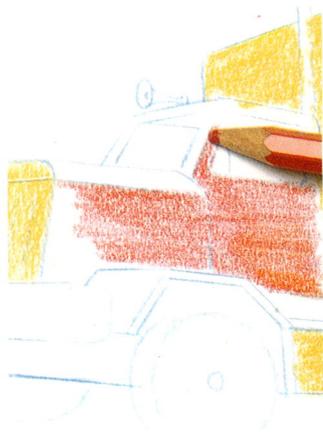

Colour the lower area of the cab. Draw the outline of the window and the windscreen in the upper area.

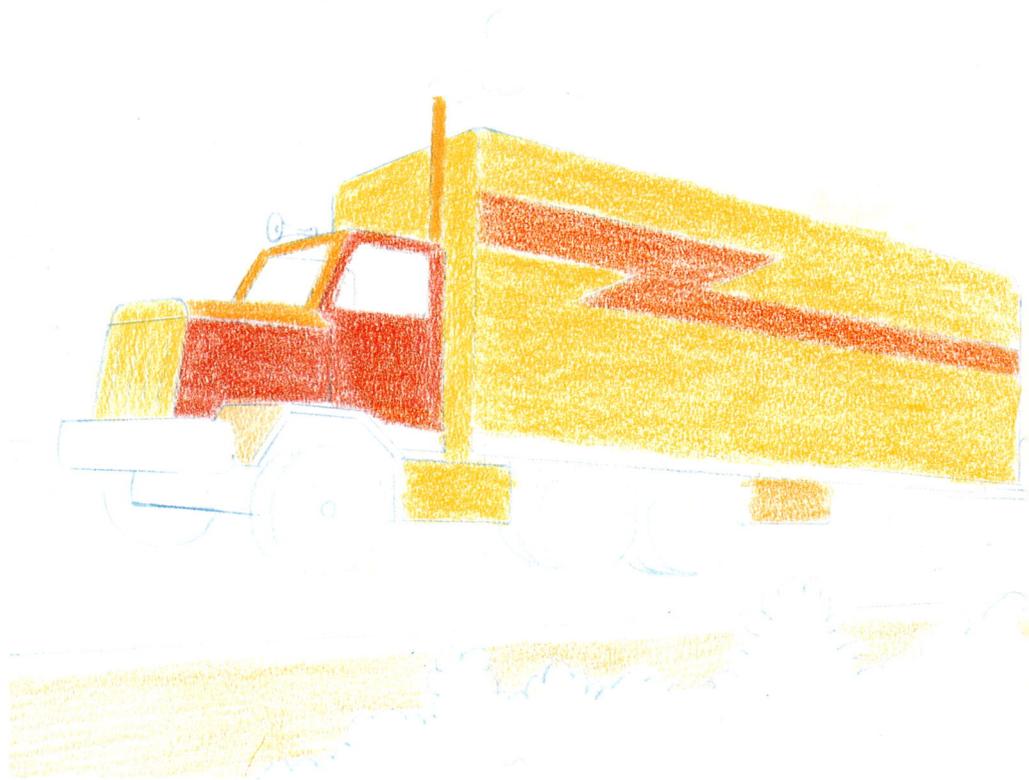

Use red to colour the cab. Don't worry if you cover the blue lines of your original outline. Colour the design on the lorry red.

Sharpen the orange pencil; you will need a very sharp point to draw the exhaust pipe and the upper part of the bonnet.

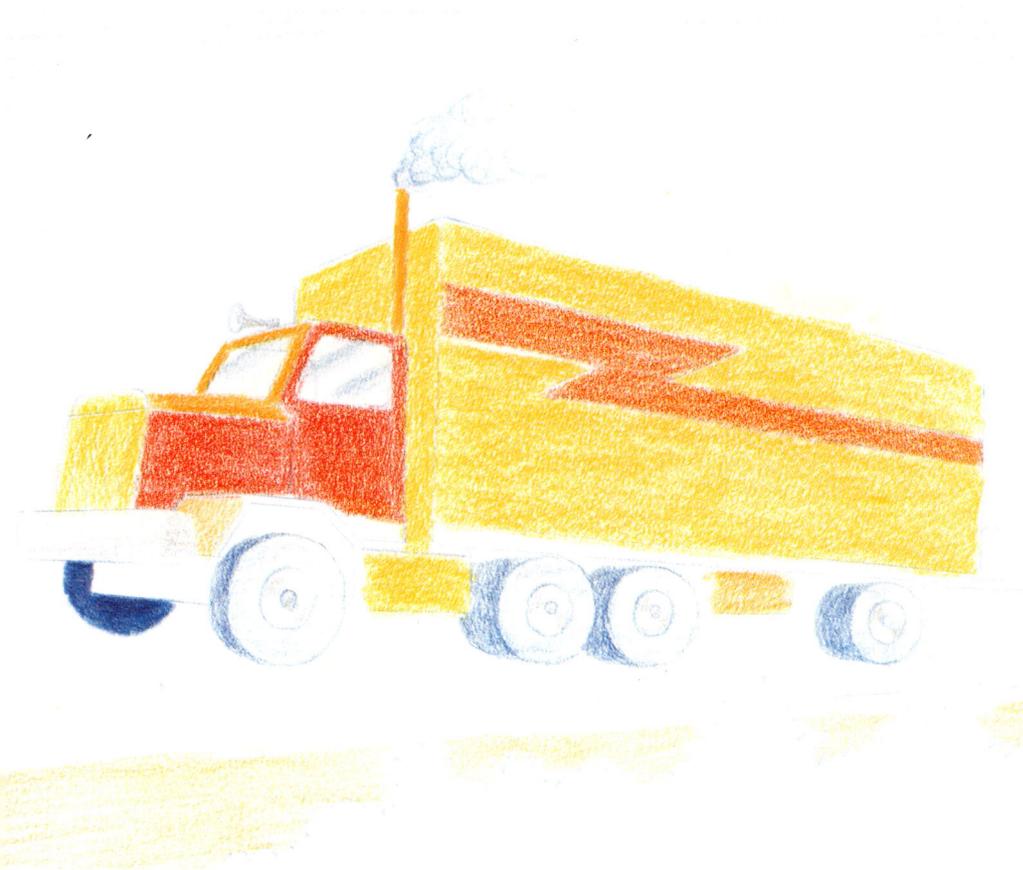

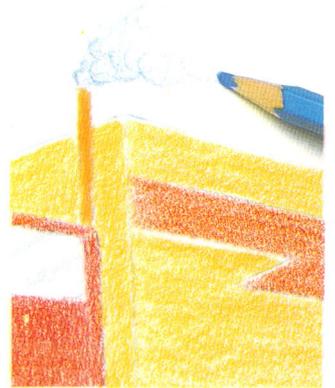

Now move on to using just the blue crayon. This will help you practise making different tones of a colour.

Gradate the sky with light blue and also use light blue for the reflections on the window glass, the tyres and the exhaust smoke.

Colour the sides of the wheels with dark blue, pressing very hard for the left front wheel.

43

Advanced projects

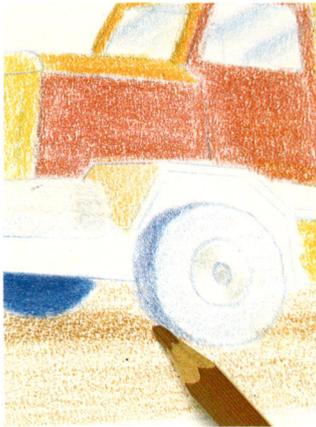

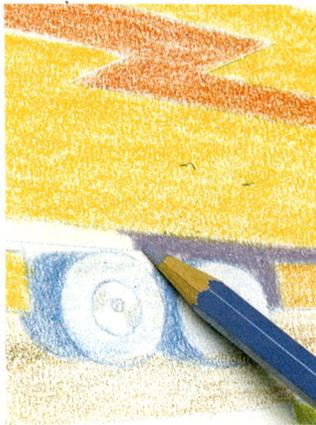

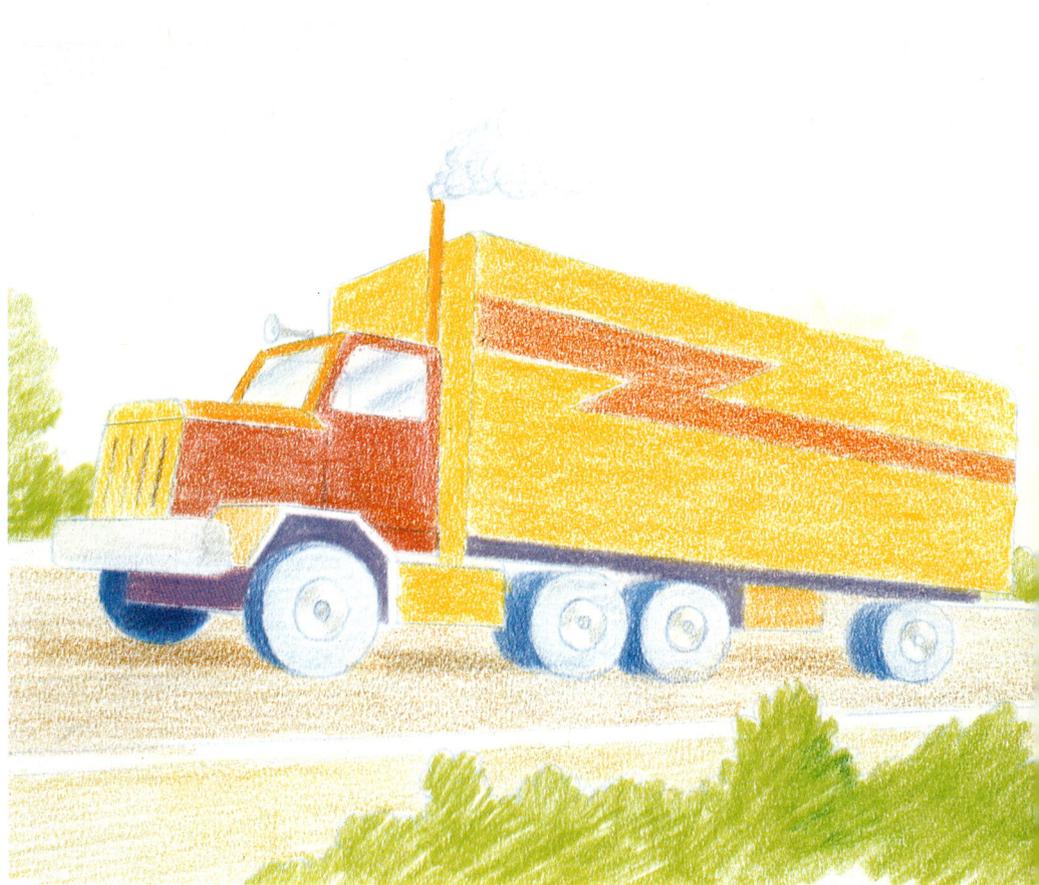

Use light green and make strong strokes holding the pencil horizontal to the paper, to colour the bushes in the foreground and background.

Apply a first layer of light brown to the road, pressing the pencil harder for the shadow of the lorry. Use purple under the bumper and the back of the lorry.

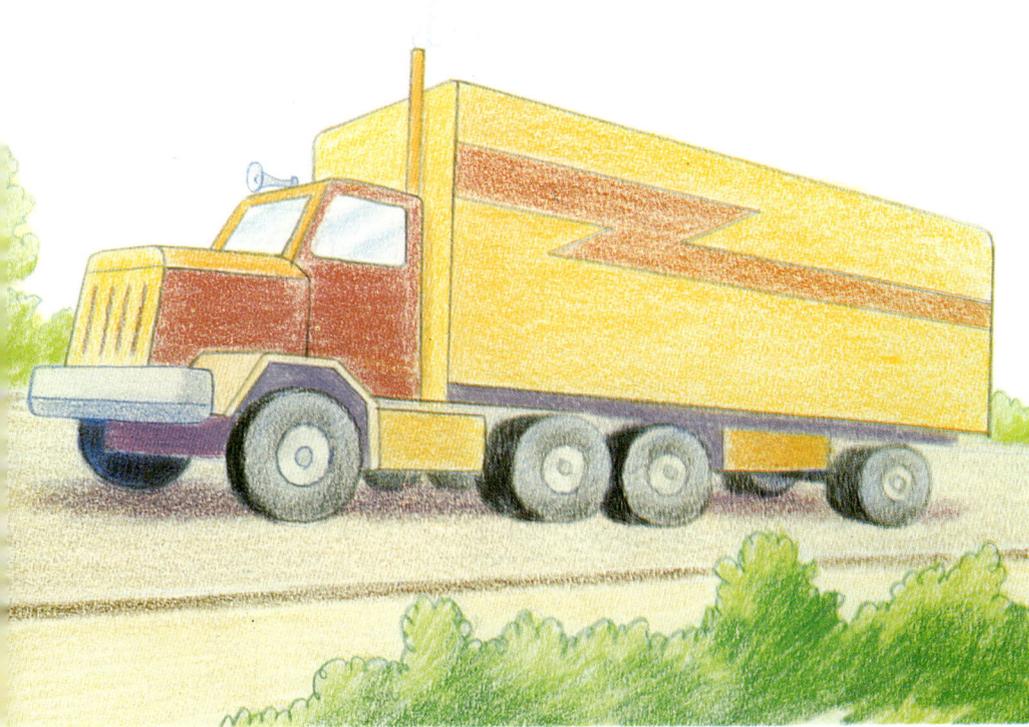

Harmonize the yellow background with vertical strokes in yellow ochre. Hold the pencil horizontal to the paper and press gently to avoid obvious strokes.

Without pressing hard on the paper, shade the cab with vertical strokes of light brown.

Retouch and draw in the outlines of the wheels in black, and use purple in the shadows.

Mix dark blue with the brown of the road.

Draw all the outlines with dark green for the bushes, dark blue for the horn and the bumper and dark brown for the radiator grille and the exhaust pipe.

Glossary

colour wheel. A circle made up of twelve colours: three primary colours, three secondary colours and six tertiary colours. Another name for colour wheel is chromatic circle.

complementary colours. The secondary colour created by mixing two primary colours is complementary to the third primary colour (for example, green, obtained by mixing blue and yellow, is complementary to red).

composition. The arrangement of all elements of a subject in a pleasing way.

cool colours. The colours in the colour wheel between green and violet, with both these colours included.

form sketch. First lines in a drawing that set down the basic forms of a subject using simple geometric shapes (squares, rectangles, circles, etc).

gouache. A technique of painting in which watercolours are mixed with opaque white pigments. This makes the colours lose their transparency.

gradation. The gradual shift from a darker tone to a lighter one or vice versa.

graphic arts. Printmaking, including etching, engraving, lithography, and other ways of producing multiple copies of a picture.

grid. A box containing evenly spaced horizontal and vertical lines that is used when making a copy of a drawing.

harmonize. Set down colours so that none clashes with the other.

kaolin. A fine, white clay that is mixed with pigments to make the 'lead' of coloured pencils. Kaolin is also used to make porcelain.

outline. A quick sketch that with a few lines sets down the basic elements of a subject.

pigment. A coloured powder made from earth, finely ground stones, vegetables, chemicals, etc which is mixed with a medium such as oil to make paints or with wax and clay to make crayons.

primary colours. Red, blue and yellow; the colours that are blended to produce other colours, but that cannot themselves be created by mixing.

scale. A group of all the tone variations in a colour.

secondary colours. Orange, purple and green; the colours created by blending pairs of primary colours.

shading. Capturing light and shadows through gradation of different tones.

sketch. A rough drawing or painting in which the shape, composition and tonal values of light and shadows are shown.

still life. A drawing or painting based on a collection of objects arranged in a particular way by the artist.

tertiary colours. The colours created by blending a primary and secondary colour (for example, blue-green or red-orange.)

tones. Intensities of a colour, from the lightest to the darkest.

transparent colour. A layer of colour through which the colour underneath can be seen.

value. The degree of lightness or darkness of a colour. A weak value is very light (or pale); a strong value is dark and intense.

warm colours. The colours in the colour wheel between crimson and light yellow, with both these colours included.